WRITINGS ON ART

EDITED AND WITH AN INTRODUCTION, ANNOTATIONS, AND
CHRONOLOGY BY MIGUEL LÓPEZ-REMIRO

YALE UNIVERSITY PRESS
NEW HAVEN AND LONDON

MARK ROTHKO

WRITINGS ON ART

Cover image: Henry Elkan, *Portrait of Mark Rothko*, 1954. Courtesy of the Rudi Blesh papers, 1909–1983, in the Archives of American Art, Smithsonian Institution.

Transcription of "Scribble Book" compiled by Miguel López-Remiro, with textual emendations by the Getty Research Institute, ©2005 Éditions Flammarion, Paris.

Introduction, annotations, and chronology translated by Karen Gangel.

Set in Minion and Syntax type by Amy Storm

Printed in the United States of America by Thomson Shore

Library of Congress Cataloging-in-Publication Data
Rothko, Mark, 1903–1970.
Writings on art / Mark Rothko; edited and with an introduction, annotations, and chronology by Miguel López-Remiro.
 p. cm.
Includes bibliographical references and index.
ISBN-13: 978-0-300-11440-9 (cloth: alk. paper)
ISBN-10: 0-300-11440-0 (cloth: alk. paper)
1. Rothko, Mark, 1903–1970—Written works. 2. Rothko, Mark, 1903–1970—Correspondence. 3. Artists—United States—Correspondence. I. López-Remiro, Miguel. II. Title.
N6537.R63A35 2006
759.13—dc22
2005032790

A catalogue record for this book is available from the British Library.

The paper in this book meets the guidelines for permanence and durability of the Committee on Production Guidelines for Book Longevity of the Council on Library Resources.

10 9 8 7 6 5 4 3 2 1

ROTHKO'S WRITINGS ON ART

CONTENTS

Acknowledgments

I wish to thank the many institutions and individuals that provided support during the preparation of this work. First, I want to express my gratitude to the Cátedra Félix Huarte de Estética y Arte Contemporáneo at the University of Navarre, Spain, where I was a research fellow during the writing of my thesis— my point of departure for this work. At that institution, I wish to thank Professor Álvaro de la Rica, who introduced me to Rothko, and María Josefa Huarte, for her enthusiasm and her confidence in my work. Thanks to my thesis advisor, Professor María Antonia Labrada, University of Navarre, for her philosophical and artistic knowledge. I also want to thank the Visual Arts Department at the University of California, San Diego, where I was a visiting scholar under the exceptional aegis of Professor Sheldon Nodelman; thanks, too, to Professor John Welchman, who was the first to suggest that I work on Rothko's writings. I would especially like to thank Maxime Catroux, Éditions Flammarion, for editing this book. I also wish to thank the staff at Yale University Press, especially Michelle Komie, Patricia Fidler, and Dan Heaton, for the editing and production of the English-language edition of the book.

Finally, I thank the Rothko family for their contribution to this work.

Miguel López-Remiro

Introduction

Mark Rothko (1903–1970) is today recognized as one of the most influential and important artists of the twentieth century. Thirty-six years after his death, Rothko's work continues to interest the art and publishing worlds.[1] It also inspires art lovers, as evidenced by the tremendous success of the retrospective presented in 1998 by the National Gallery of Art in Washington and the Whitney Museum of Art. Although Rothko is one of the twentieth century's most discussed and exhibited artists, his writings have yet to be studied. By the end of the century, only a dozen texts by Rothko, edited by Bonnie Clearwater, curator of the Mark Rothko Foundation, were available to the public. Even these were known only to Rothko scholars.[2]

This paradox contrasts with the legacy of many of his contemporaries, who, like Rothko, were members of the New York School: Robert Motherwell, Barnett Newman, or Ad Reinhardt, for example, whose writings are well known.[3] In Rothko's case, this void has perpetuated the idea that he wrote only a dozen texts or essays in all. And because these texts preceded Rothko's adoption of abstract expressionism, this apparent silence has been interpreted as a personal renunciation of the written word, as if the silence were part of his pursuit of abstraction.

In truth, Rothko wrote throughout his career. The appearance in 2004 of *The Artist's Reality,* a manuscript that went unpublished for more than sixty years, is a striking example.[4] The association between Rothko's abstract period and the silence that followed is definitively dispelled by *Writings on Art*: half of the texts that make up this book were written after 1950 — that is, during the time he was exploring abstraction in his paintings.

Few of his contemporaries displayed the deep knowledge of art and philosophy that emanates from Rothko's writings.[5] The reader of *The Artist's Reality* finds, above all, a theoretical book, with no biographical references. Moreover, Christopher Rothko, in his introductory essay, stresses that his father never uses the singular pronoun "I" in this text.[6] Written around 1940, on the eve of a major

artistic breakthrough—the realization of the limits of representational art and the beginning of a movement toward abstraction—*The Artist's Reality* is testimony to an intense period of reflection. This is also evoked in the present collection of writings:

> *The last phase of this direction [the figurative stage] in my work was exhib-*
> *ited by J. B. Neuman in his galleries in 1939. Shortly thereafter, I became*
> *convinced of the limitations of that tendency for the expression of my whole*
> *equipment and predilections. I stopped painting and spent nearly a year*
> *developing both in writing and in studies my ideas concerning the Myth and*
> *anecdote which are the basis of my present work [the surrealist stage, which*
> *includes the years 1941 through 1947].*[7]

At the end of the 1930s and the beginning of the 1940s, members of the New York School became acquainted with the European avant-garde who were in exile in the United States during World War II.[8] It was in this climate of exchange, thought, and study, between 1939 and 1941, that Rothko wrote *The Artist's Reality*. His painting style also changed direction, from the figurative to the surreal. Rothko no longer painted the human figure, though he wanted to express the symbol:

> *I belong to a generation that was preoccupied with the human figure and I*
> *studied it. It was with the most reluctance that I found that it did not meet*
> *my needs. Whoever used it mutilated it. No one could paint the figure as it*
> *was and feel that he could produce something that could express the world.*
> *I refuse to mutilate and had to find another way of expression. I used mythol-*
> *ogy for a while substituting various creatures who were able to make intense*
> *gestures without embarrassment. I began to use morphological forms in order*
> *to paint gestures that I could not make people do.*[9]

Redefining the concepts of form, space, beauty, abstraction, myth, Rothko wished to raise painting to the same level of intensity and emotion as music and poetry. He therefore renewed the basic inspiration of *ut pictura poesis* (as is painting, so is poetry), which, since the Renaissance, has driven great painting. In this sense, *The Artist's Reality* can be read as a book of the "last of the old masters."[10]

Marcus Rothkowitz was born on September 25, 1903, in Dvinsk, Russia (currently Daugavpils, Latvia). He was the fourth and last child of Jacob Rothkowitz, a pharmacist. The family emigrated to the United States when he was ten and settled in Portland, Oregon. Rothko studied at Yale University for two years with the goal of becoming a lawyer or engineer. In 1923, however, he gave up his studies and

moved to New York. There he took design and painting courses under the tutelage of Max Weber, who encouraged him to study Cézanne.[11] Rothko then met Milton Avery, with whom he took part in a first group show in 1928.[12] The following year, as the United States was approaching economic crisis, Rothko began to teach design and painting to children of the Brooklyn Jewish Academy, a defining experience he pursued for more than twenty years, the many details of which are evoked in his early writings. His first one-man exhibitions, launching his career as a painter, took place in 1933 at the Museum of Modern Art in Portland and at the Contemporary Art Gallery in New York. During the thirties his leanings toward expressionism became evident, especially in domestic and urban scenes. In 1940 he entered a new stage, marked by surrealism. Gradually, the human figure disappeared in favor of mythological or natural motifs. In 1945 he showed for the first time in Peggy Guggenheim's gallery, and in 1946 he joined Betty Parson's gallery.

The next important turning point in Rothko's career took place in 1947. He "replaced," for good, the surrealist theme with abstract forms, which he labeled "multiforms."[13] In 1948 he was, along with Robert Motherwell, William Baziotes, and David Hare, one of the founding members of an art school called The Subjects of the Artist.[14] In 1954 he joined the Sidney Janis Gallery, and ten years later he began showing at the Marlborough Gallery. After Rothko suffered a ruptured aneurysm in 1968, his doctors forbade him from painting works measuring more than forty inches in height. In 1969 he received an honorary doctorate from Yale; one year later he committed suicide in his New York studio. His posthumous work the Rothko Chapel, financed by the Menil family, was inaugurated one year later.

The approximately one hundred texts assembled in this book, written between 1934 and 1969 — that is, from one year after his first one-man exhibition to one year before his death — trace the evolution of Rothko's aesthetic thought throughout his career. But these writings, landmarks of a life of painting and of the man, also form a sort of intellectual and emotional self-portrait of Mark Rothko.

In the first of these texts, dated 1934, "New Training for Future Artists and Art Lovers," Rothko relates his teaching experience at the Brooklyn Jewish Academy. An analysis of how children experience art raises many questions: Do the child and the madman have comparable attitudes toward art? How does one unlearn conventional techniques of perception in order to see through the eyes of the artist? More generally, Rothko questions the validity of art instruction and sees himself as the advocate of its reform. The last text, dated 1969, is his acceptance speech upon receiving an honorary doctorate from Yale. It is at present the last known document written by Rothko, edited several months before his death. *Writings on Art* includes all the texts Rothko published in magazines, journals, and

exhibition catalogues from 1937 to 1969. It also features Rothko's important correspondence not only with artists of the New York School but with historians, gallery owners, and museum curators. Also included are transcriptions of notebooks, conferences, and interviews.

All these documents allow us to sharpen our biographical and artistic perception of Rothko. The artistic risks of his painting career appear throughout the work, no longer from the theoretical point of view, as in *The Artist's Reality*, but from a practical, experiential, and personal perspective. If, as his son observed, *The Artist's Reality* mentions neither the "I" of the author nor his own work, in *Writings on Art*, Rothko makes up for this by discussing his works in almost all the texts.

One example clearly illustrates this difference. In the mid-1940s Rothko began a major new transition in the development of his career with the abandonment of surrealist painting and the introduction of his "multiform" abstractions, which preceded his abstract expressionist works. In search of a purer form of symbolism, Rothko in 1945 wrote to the painter Barnett Newman: "I have assumed for myself the problem of further concretizing my symbols, which give me many headaches but make my work rather exuberating. Unfortunately we can't think these things out with finality, but must endure a series of stumblings toward a clearer issue."[15]

Another letter, addressed to Clay Spohn, professor at the California School of Fine Arts, makes note of the same preoccupation: "Elements occurred there, which I shall develop, and which are new in my work, and that at least for the moment stimulates me—which gives me the illusion—at least—of not spending the coming year, regurgitating last year's feelings."[16]

As personal testimonies of the advances that occurred all along Rothko's artistic path, these writings reveal a multitude of themes despite, as Sheldon Nodelman has noted, the unity of thought that runs through this collection: thanks to these texts, one meets an intellectual with one primary thought.[17] The quest that underlies Rothko's entire oeuvre consists in conceptualizing art as *myth*, as *drama*, as an *anecdote to the spirit*.[18] He is in search of a symbol of permanence.

From a formal point of view, these texts can be divided into four major groups: the first is a collection of letters Rothko wrote to contemporary artists, such as Newman, Herbert Ferber, Avery, Motherwell, or Stanley Kunitz. He wrote to distant colleagues from New York, but also when he traveled within the United States and in Europe.[19] Although these letters are always related to art, they also contain many elements that reveal a more personal Rothko. They are a firsthand account of his life and friendships with fellow artists. The second group of writings

comprises letters of a "musiographic" nature. Addressed to exhibition representatives and museum directors, they touch upon, in particular, everything involved in the organization of an exhibition. Of special interest is Rothko's correspondence with the art critic and curator Katharine Kuh. In 1954 she proposed to Rothko a one-man show at the Art Institute of Chicago, his first in an important museum. For the occasion, she hoped to publish a text titled "An Interview with Mark Rothko," a project that was never realized.[20] Still, the thirteen letters that Rothko then sent to Kuh have survived. They refer as much to the installation of works as to questions of theoretical order raised by the curator. Unedited until now, the letters provide prime material for understanding how Rothko envisioned his work. A third group of texts refers to the teaching of art. Rothko was forever tied to education, as evidenced in the 1934 article mentioned earlier, the notebook called "Scribble Book," and even in *The Artist's Reality*. Beginning in the late 1940s he accepted teaching posts at several universities.[21] The fourth group shows how he approached the communicative role of the vision of art. Throughout numerous texts, Rothko continued to reflect on this concept of art as a means of communication, particularly beginning in the 1950s, when the empathy between the work and the viewer became one of the key elements of his artistic theory. This aesthetic preoccupation coincided with the appearance of his abstract expressionist style. His works became transformed into a scene of communication with the viewer. In 1958 at a conference at Pratt Institute, he defined his painting as "facades": "My pictures are indeed facades (as they have been called). Sometimes I open one door one window or two doors and two windows. I do this only through shrewdness. There is more power in telling little than in telling all."[22]

Rothko bet on a concept of art as communication, of art as exchange. It is the creation of an imaginary space of communication between the artist, the painter, and the viewer: "I want to put you back in."[23] Let us wager that, given the insight into Rothko's work that is now available to us, these *Writings on Art* will reimmerse us in this shared space.

Miguel López-Remiro
October 31, 2005

1 Important publications on Rothko have appeared in recent decades. Of special significance is the catalogue raisonné of his oil paintings by David Anfam: *Mark Rothko: Works on Canvas* (New Haven: Yale University Press, 1999); publication of his works on paper is scheduled for 2007. Several retrospective catalogues are also of note: see those by Diane Waldman, *Mark Rothko, 1903–1970: A Retrospective* (New York: Harry N. Abrams, 1978), and Jeffrey Weiss, *Mark Rothko* (New Haven: Yale University Press, 1998), in conjunction with exhibitions in Washington, D.C., New York, and Paris. Two other works address biographical aspects of Rothko's life: Dore Ashton, *About Rothko* (New York: Oxford University Press, 1983), and James E. B. Breslin, *Mark Rothko: A Biography* (Chicago: University of Chicago Press, 1993). Among books devoted to the analysis of his work, see Anna C. Chave, *Mark Rothko: Subjects in Abstraction* (New Haven: Yale University Press, 1989), as well as several detailed studies, such as that by Sheldon Nodelman, *The Rothko Chapel Paintings* (Austin: University of Texas Press, 1997), and the volume on his murals for the Seagram Building: *The Seagram Mural Project*, with text by Michael Compton (London: Tate Gallery, 1988). In 2005 the Getty Research Institute published *Seeing Rothko*, edited by Glenn Philips and Tom Crow, which includes articles by Jeffrey Weiss, Charles Harrison, and me.

2 *Mark Rothko, 1903–1970*, exhibition catalogue, with texts by Bonnie Clearwater, Michael Compton, Dana Cranmer, Robert Goldwater, Robert Rosenblum, Mark Rothko, Irving Sandler, and David Sylvester (London: Tate Gallery, 1987).

3 S. Terenzio, ed., *The Collected Writings of Robert Motherwell* (New York: Oxford Universitiy Press, 1992); J. P. O'Neill, ed., *Barnett Newman: Selected Writings and Interviews* (New York: Knopf, 1980); B. Rose, ed., *Art as*

Art: The Selected Writings of Ad Reinhardt (New York: Viking, 1975).

4 Mark Rothko, *The Artist's Reality: Philosophies of Art* (New Haven: Yale University Press, 2004). This manuscript was discovered accidentally in 1988 during the course of an inventory. Mark Rothko's son, Christopher, edited and wrote an introduction for the book.

5 As Anne Seymour as shown in *Beuys, Klein, Rothko: Transformation and Prophecy* (London: Anthony d'Offay Gallery, 1987), 11, among the artists of the New York School, Rothko was one of the most well grounded intellectually; he was an expert in both Judeo-Christian and Greek tradition, particularly Plato and Greek tragedy, and in the works of Shakespeare, Nietzsche, and Kierkegaard.

6 Christopher Rothko, Introduction to Rothko, *Artist's Reality*, xxv.

7 Mark Rothko, Brief Autobiography, ca. 1945, page 42 this volume.

8 For members of the New York School like Rothko, this exile of the European avant-garde to New York provided the opportunity to establish, through exposure to a set of artistic concepts, an avant-garde in America (Jonathan Fineberg, *Art Since 1940: Strategy of Being* [New York: Harry N. Abrams, 1995], 30). Even if Rothko never considered the surrealists' doctrine valid, or if he did not accept their dreamlike symbolism, contact with the European avant-garde greatly influenced his style. "While the Surrealists were interested in translating the real world to dream, we were insisting that symbols were real" (Mark Rothko, interview by William Seitz, 25 March 1953, page 85 this volume).

9 Transcript of a conference at Pratt Institute, New York, November 1958, page 125 this volume. In this text Rothko stressed how painting based on familiar objects may evoke a materialistic response on the part of the viewer, one that blends the *object matter* and the *subject*

matter. See also Chave, *Rothko,* 28. Rothko's objective was to succeed in painting a symbol; since the human figure did not lend itself to being painted as a series of symbols, the search for a timeless language became the key to his artistic vocabulary. See Waldman, *Mark Rothko,* 43.

10 Daniel Arasse, "La solitude de Rothko," *Art Press* 241 (December 1998): 27–35.

11 Max Weber was a painter and teacher at the Art Students League. He was, among other artists, one of Rothko's teachers. Born in Russia in 1881, Weber immigrated to the United States in 1891. In 1905 he moved to Paris, where he became a pupil of Matisse and a friend of Picasso, Rousseau, and Apollinaire. By 1909, upon his return to New York, he had evolved into one of the major representatives of modern art in the United States and was part of the avant-garde group of artists in Alfred Stieglitz's circle. Weber produced the first American cubist paintings.

12 Milton Avery was born in New York in 1885. In the 1920s he developed a personal style indebted to the European modernism of Matisse. His work became an important link between the young modern American art movement and art of the European avant-garde. "Avery simplified natural landscape and the human figure into flat, lyrical areas of opaque color, and by doing so he became the historical link between European modernism and the *color-field* wing of American Abstract Expressionism," wrote Breslin (*Mark Rothko,* 95). The influence of Avery on Rothko is paramount; Rothko considered him his master: "This conviction of greatness, the feeling that one was in the presence of great events, was immediate on encountering his work. It was true for many of us who were younger, questioning, and looking for an anchor. This conviction never faltered. It has persisted, and has been reinforced through the passing decades and the passing fashions" (Tribute to Milton Avery, 1965, page 149 this volume). Rothko met Avery at the end of the 1920s. He attended Avery's weekly meetings on art and his design sessions. Avery was the first artist with whom he became friends.

13 In a conversation with the historian William Seitz in 1952, Rothko defended the choice of these new forms, which, for him, represented neither an elimination of nor a passage to the essence of his work but rather a symbolic substitution. "These new shapes say, he said, what the symbols said. Areas are things. 'Not a removal but a substitution of symbols'" (Interview with Seitz, January 22, 1952, page 75 this volume).

14 The objective of this school was to organize meetings on art. It had neither courses nor official members but promoted "spontaneous investigation into the subjects of the modern artist—what his subjects are, how they are arrived at, methods of inspiration and transformation, moral attitudes, possibilities for further explorations" (school announcement, The Subjects of the Artist, New York, 1948–1949).

15 Letter to Newman, July 31, 1945, page 47 this volume.

16 Letter to Spohn, September 24, 1947, page 55 this volume.

17 Borrowing Isaiah Berlin's term, Mark Stevens called Rothko a "hedgehog" painter. This concept refers to a thinker who appeals to unitary thought, as opposed to a "fox," a thinker who pursues several goals that are independent of one another—indeed, contradictory. Stevens defends the thesis that even if Rothko searched throughout his career, it is also clear that the nucleus of his proposition can be described as a unity, "oneness." "Mark Rothko," in *Mark Rothko: "Multiforms" Bilder von 1947–1949 / Herausgegeber Daniel Blau* (Ostfildern: Hatje, 1993), 11.

18 "For art to me is as anecdote of the spirit,"
Personal Statement, 1945, page 45 this volume.

19 His trip to Italy had a major impact on him.
After visiting the temple of Paestum, Rothko
declared: "I have been painting Greek temples
all my life without knowing it." See John Fischer,
"The Easy Chair," page 130 this volume.

20 See Breslin, *Mark Rothko*, 307–312.

21 From 1947 to 1949 he was a guest instructor at
the California School of Fine Arts; from 1951
to 1954 he was assistant professor in the
Department of Design at Brooklyn College;
during the summer of 1955 he taught at the
University of Colorado, Boulder; and in 1957
he was visiting artist at Tulane University, New
Orleans.

22 Conference at Pratt Institute, 1958, page 125
this volume.

23 Interview by William Seitz, January 22, 1952,
page 75 this volume.

Note to the Reader

This book brings together all the writings by Mark Rothko found in public collections, principally the Archives of American Art at the Smithsonian Institution; the National Gallery of Art, Washington, D.C.; the Getty Research Institute in Los Angeles; and the Art Institute of Chicago. Also included are original texts by Rothko in the possession of his descendants.

The main part of this collection was part of my doctoral thesis, "La Poética de Mark Rothko," University of Navarre, 2003, a study of the philosophy and art implicit in Rothko's work. Professor Sheldon Nodelman, a renowned authority on Rothko, suggested that I publish this collection, in light of the interest in and uniqueness of these texts. The new documentary material presented in this book will continue to enrich Mark Rothko studies.

This book presents Rothko's texts as he wrote them. The largest part consists of manuscripts that had to be transcribed. Words that could not be deciphered are indicated as such in an explanatory note. Certain texts have the fragmentary quality—sometimes elliptical, sometimes unclear—of jottings that initially were never intended for publication. Obvious typographical errors in published texts have been corrected, but no editorial liberties have been taken with typescript and manuscript texts. The goal in publishing these works is to remain true to the originals.

When necessary, notes have been added to names and events to which Rothko alludes. Biographical notes, except where otherwise specified, are based on the biography of Mark Rothko by James Breslin.

WRITINGS ON ART

"New Training for Future Artists and Art Lovers," 1934

The significance of this exhibition lay (1), in the indication of the potentialities of children to use a medium of expression, considered the heritage only of the highly gifted, the well-trained and the experienced; (2), in the intrinsic value of this work as art, and (3), in the value of such expressions both in the development of appreciation of art and in the future creation of art by those of the children who may be inclined to continue painting or sculpture as a major interest in life.

Laymen usually have a wrong conception of the relationship of natural talent, training and experience to art. Of course, no one will deny the benefits of long experience, discipline, and above all, talent. Yet we may look at the matter in a different fashion. Our children, as well as ourselves, employ the common medium of speech. We all tell stories, narrate events, indulge in correspondence, sometimes with great feeling and artistry. Yet, we do not feel that our expression in this medium is dependent on our knowledge of grammar, syntax or the rules of rhetoric. Likewise we sing melodies and improvise tunes for ourselves and I am sure that we can do both without voice culture and a knowledge of harmony and counterpoint. Painting is just as natural a language as singing or speaking. It is a method of making a visible record of our experience, visual or imaginative, colored by our own feelings and reactions and indicated with the same simplicity and directness as singing or speaking. If you do not believe this, watch these children work, and you will see them put forms, figures and views into pictorial arrangements, employing of necessity most of the rules of optical perspective and geometry, but without the knowledge that they are employing them. They do so in the same manner as they speak, unconscious that they are using the rules of grammar.

Brooklyn Jewish Center Review 14 (February–March 1934): 10–11. Signed Marcus Rothkowitz, this is the first publication by Rothko in a professional venue. As an artist who gives classes to young children whose works are exhibited, he presents, at the request of the journal editor, what he considers to be the keys to artistic education. Rothko defends an innate and natural vision of painting: a language as natural as speech.

It is just with that simplicity that we allow the children in our class to paint, and that is why, perhaps, their paintings are so fresh, so vivid and varied. And it is these qualities, which, no matter how skilled an artist may be, he must obtain to make his work arresting and provoking of attention.

Let me describe how our children work. They enter the art room. Their paints, paper, brushes, clay, pastels—all the working material is ready. Most of them, full of ideas and interests, know just what they want to portray. Sometimes it is something from the history lesson, sometimes from Hebrew history; at other times, something they might have seen in the movies, on a summer trip, on a visit to the docks or at a factory, or some scene observed on the street; often it is a subject that is born entirely in their own minds as a result of reflection, or of particular sympathies and dreams.

They proceed to work. Unconscious of any difficulties, they chop their way and surmount obstacles that might turn an adult grey, and presto! Soon their ideas become visible in a clearly intelligent form. As their experience increases, they gain in sureness, and soon nothing is too difficult. They handle crowds, vistas, panoramas, landscapes, portraits—every conceivable idea, with the same ease that a more timid person might draw a simple house.

The function of the instructor is to stimulate and maintain their emotional excitement, and suggest solutions of difficulties which might prove a snag, and above all to inspire self-confidence on their part, always, however, taking the utmost care not to impose laws which might induce imaginative stagnation and repetition. Then, too, the instructor, by approving or disapproving, maintains a standard as to the amount of realization which the child must attain in his work before it is laid aside.

As a result of this method, each child works on his own idea, and actually develops a style of his own whereby his work is distinguishable from everyone else's. He achieves a skill and personal technique of representing his ideas. Working side by side, as these children do, you will never see them copying or being influenced by another's work. Hence the variety, the skill, the sureness which were visible in our exhibition.

As an example of the community spirit found in this art class, the following incident may be cited. One of the boys was at a loss for a subject. The instructor suggested a painting based on something he had seen on a visit to a factory or other plant. The boy had never been in such a place, but a girl standing near by came to his assistance. She had visited a cotton gin on a recent trip and was able to describe it to him. The two decided to do a joint painting, one supplying the

details for the picture and the other giving them pictorial illustration by means of paint and brush.

That is, they are complete realizations of a subject that moves us by the beauty of its moods, by the fulness of its forms, and the excitement of its design. In short, many of these pieces are capable of moving us emotionally. Without going into an involved discussion of the aesthetics involved, that is more or less what fine works of art do to us. It is significant, that dozens of artists viewed this exhibition and were amazed and stirred by it.

These children have ideas, often fine ones, and they express them vividly and beautifully, so that they make us feel what they feel. Hence their efforts are intrinsically works of art.

Our critics of art, poetry, music, theatre and movies deplore that so many artists occupy themselves with precious themes, such as still life in painting, decadent amatory situations in the drama and literature and futile atonalities in music. They accuse our artists of being unsocial, that they neglect the life about them, and urge that they turn toward the surging tide which is their life. Well, let the critics view our children's work. Everything is there: factories, docks, streets, crowds, mountains, lakes, farms, cattle, men, women, ships, water—everything conceivable. Here is a social art.

Most of these children will probably lose their imaginativeness and vivacity as they mature. But a few will not. And it is hoped that in their cases, the experience of eight years will not be forgotten and they will continue to find the same beauty about them. As to the others, it is hoped, that their experience will help them to revive their own early artistic pleasures in the work of others.

It should be noted that while about a hundred and fifty works were shown in the Brooklyn Museum more than twice that number could have been selected with equal justification. Only the limitations of the available wall space reduced the selection to the number exhibited.

Similarly, practical reasons confined the selections for illustrating this article to only five subjects. Some of the paintings which were admired could not be used because they would not have reproduced well in print.

"Scribble Book," ca. 1934

All of these purposes can be served best by the proper development of the subject in the spirit of utmost integrity to its own materials — except in cases of abnormality where a temporary "white lay" might, ~~and~~ debately, be considered therapeutically expedient.

The creative art work ~~of~~ itself no longer needs an army to defend it. Since Cizek[1] had made his starting experiments at the close of the last century, it has been gaining wider and wider adherence. At first practiced by a handful of adventurers in education, it is now penetrating degree by degree into the most strongly fortified citadels of conservatism. A term hardly passes but some additional public school adopts it. Sometimes parents group who had been undermined by tales of the wonders achieved, begin extra-curricular classes in the very school building, an ironic protest against its absence in the school curriculum.

The time has now come to examine our results, to evaluate them. Until now ~~we~~ there has been a united front, erasing all differences, in the apostleship for the general cause. At this time, I am presenting an analysis of what has occurred.

Mark Rothko, Manuscripts and Sketchbook, ca. 1935–1943; acc. no. 2002.M.8 (box 2). Research Library, Getty Research Institute, Los Angeles. The "Scribble Book" is a collection of notes for a book or manual on teaching children's art. Breslin notes that "Rothko's critics have generally viewed *The Scribble Book* as the source of a Center Academy talk given by Rothko in 1938.… Yet the Scribble Book was not just a prose laboratory for preparing this 1938 Center Academy talk." The "Scribble Book" was a preparation for a book that Rothko never published: "Rothko's papers contain a title page, an elaborate three-page outline and about ten pages of drafts for what would become a long essay or short book comparing "the basic plastic elements, styles and processes common to both the creative paintings of children and traditional art. It was this work, far more ambitious, sophisticated, and systematic than the Center Academy talk, but apparently never completed, for which the *The Scribble Book* was preparation." James E. B. Breslin, *Mark Rothko: A Biography* (Chicago University Press), 1993, 130–131. The book's outline and around ten pages of typescript drafts of the book that have survived and are kept in Rothko's papers are included in this volume as "A comparative analysis."

1. Franz Cizek, artist and teacher at the School of Applied Arts in Vienna.

Setting aside the notion that creative act is a social action and that intrinsically in ~~itself~~ it justifies its own existance. This is borne out by the beauty and vitality of the work achieved[2] in itself and as such is a contribution to our cultural heritage which the viewing of which will afford perhaps more pleasure to us and in the future than even the making of it to the children, if that can be possible. And recreation is a social good.

However there are certainly limitation which we have encountered which we should now be able to examine.

(1) First that the creative period is at best short lived.
(2) p. 7[3] That complete individuality is preserved only for a short period, which is often
(3) followed by a primitivism which while it simulates the life of youth, has really lost its personality and assumes that of the teacher and his prejudices. That such a creative experience should contribute to the student's future development.

Heretofore our most successful work has been done by the artist teacher. The artist teacher has this distinct advantage. Thru his experience as a practitioner with his own picture and his knowledge of the plastic language in his contact with the cultural heritage, he has acquired a sensibility. This sensibility causes him to react to the merits of the child's work, understand its validity, sincerely encourage it, and to further guide it, when self consciousness develops & questions occur.[4]

This sensibility however is an inconstant factor, never being equal in two persons, sometimes tainted with prejudices by the teacher's own experience. It is desirable to augment this sensibility with knowledge, and by this time this knowledge is available, and the writer wishes to present at least ~~as~~ one aspect of it in the what is to follow. It is the hope that the practicing artist teacher will find that it ~~o~~ systematizes what he now feels, or that in the case of a teacher or parent who has not been fortunate in attaining ~~its p~~ this sensibility that herein he will find a clue for developing it.

The writer hopes that herein he will lead to a consideration ~~of a~~ and a clue to the solution of several aspects of creative painting which today face us.

2. "The first four years are a constant. The variable and questionable appears after that." Written in the left margin.
3. Rothko circled this numbered list and apparently intended to move it to the location indicated later in the text.
4. "The simple example of the teacher being able to recognize which the child has wished to represent imparts confidence and pleasure." Written in the left margin.

1^5

2 (page 3)

3

To validate this notion I must establish a series of views whose acceptance the reader must at least for the present accept (grant) to derive any benefit from this work.

(1) That an analogy exists between the art of children and these works which have occurred in the history of the world and which society has accepted as art. That the child has employed the same basic elements of plastic speech which are to be found in the works of the masters. The process of making of this analysis has been facilitated by the existance of modern art. Modern art in many of its phases has been an analytic experience. It has often in the guise of the anthropologist or archealogist ruminated among its own elementary impulses as well as the most archaic forms of man's plastic speech. It has ecclectically arranged and rearranged its discoveries. While writer consider this epoch as one of the richest and most fruitful in the history of art, the acceptance of this view is irrelevant to the case. What is fortunate that in modern art the scaffolding has been left. It has not been obscured by style and tradition as that of the old masters. It is therefore particularly useful to us as a dictionary to serve as an interpreter to establish the relationship between the child and the stream of art.

Another axiom, in the nature of a corollary is that the child, like the artist, does not use either all or any single one of these plastic elements but shows a definite proclivity toward some of them which you may say serve as the common denominator of his style.

It is the explanation of these relationships and the demonstration of these proclivities which is the theme of this work.

It is the use of this analysis for the paedagogic purposes which is the reason of this book.

(3) The proper development of the creative impulse will lead to the best and most complete experience in relationship to art itself and also Is the best possible use of this activity for such educational adjustment, and sociological ends which aim must serve in a *unified* system of education.

Wilhelm Viola:[6] "It seemed that all children unconciously followed eternal laws of form.

5. This is the location Rothko apparently intended for the earlier numbered list.
6. Viola was a disciple of Cizek. All citations of Cizek by Rothko appear in Viola's *Child Art and Franz Cizek* (Vienna, 1936). In the following paragraphs, Rothko cites Cizek as well as Viola.

The emphasis of the "Creative".

Cizek advises those to whom a certain medium becomes too easy and run the risk of becoming too skilled in that medium to try another which presents more difficulties to them.

If he were living with his children on a desert island in the ocean and could et them go on creating, he is convinced that he could bring all his children to the purest development of their creative ability.[7]

I wish to protest against the historical viewpoint. As living creative beings we must contribute to history in whatsoever fashion we function. But we have no particular obligation to fulfill the logic of history just in order to prove their point. We must follow in the logic of art, and if history did not anticipate it, it is history which must change.

History is not demonstrated by pictures, nor should pictures be demonstrated by history. I wish also to protest any demands upon our allegiance to any category of use, advertizing, functionalism, educationalism, etc.

This age of integration is the work of false correlators, interior decorators of social history and philosophy, having no relationship to truth, bending and twisting facts to commercialize their brittle machinations.

Art is of the spirit

Tradition of *starting with drawing* in academic notion We may start with color

Not our task to produce artists

For an adult the first picture is always the easiest

Stimulus will be bent to fit interests of the child.
Sources of stimulus[8] of child work — Rightly & wrongly stimulated.
Materials
Just as there is a relationship between idea & method, so must the teacher gague the best material for the child's inclination.

Subject matter stimulus
any subject will be bent to the "tendency" in the student.
eg. Shepherds.
transformed into Christ

7. Here Rothko cites an example inspired by Franz Cizek. "all his children to the purest development of their creative activity." Written in the left margin.
8. Rothko has drawn an arrow from this phrase to the previous line on the facing page.

Byzantium

Self criticism by children

The creative period—up to 10 years and how it must contribute to the next

Types of composition[9]

Scale

Rythm

Interval

Symmetry

Diagnal

Flat space &
third dimmesionalism

Spotting all over the paper

Classical and symmetrical arrangements

Diagnal and perpendicular to these diagnals and not to the pictures plane

Strip of Grass and strip of sky.

How moderns and old masters their particular sense of space

New techniques and different techniques for each method.

Absorbent surface

Non absorbent

glazing

opaque

painting into wet color

Painting around an object.

Tonalism.

A-Tonalism

Relationship between medium & technique.

Primitivism

Often child art transforms itself into primitivism which is only the child producing a mimicry of himself.

Primitivism is the exploitation of the picturesque in the charming garb of naivité

The personality of the teacher

Very often the work of the children is simply a primitive rendition of the creative ends of the artist teacher. Therefore it has the appearance of child art,

9. Rothko has drawn an arrow from this line to the line below beginning "Spotting all over . . ."

but loses the basic creative outlet for the child himself. I do not believe that the artist is completely to efface himself. The contact of a child with his teacher is as important an aspect of his environment as any other, he encounters Yet if an impirical idea were to augment the teacher artist's sensibility there would tend a finer balance in the result.

Expressionism has the greatest resemblance to the children's art. Perhaps the work is better expressionism than that of the artists themselves, since expressionism is an attempt to recapture the freshness and (naivite) of childish vision. (It is in fact a nostalgia for the innocence of childhood). It is in the more classical aspects of modernism where the laws, which underlie the plastic language of this art, are better demonstrated. They also supply a clue to parallel demononstrations in the work of the old masters

The importance of the first 4 years.

Learns manipulations

Must be completely accepted

Must not be tampered with.

The harm of influence & direction may not be seen then, but it immediately reveals itself after that age in a preoccupation with facility

Precocious facility is usually fatal, for it seeks to develope itself at the expense of the imaginative creative faculties the predecessors obscured it in style.

The psychoanalyst (Pfister[10]) may find a panorama of confessions of antipathies and obsessions among the expressionists. Yet they adopt have adopted their tradition in the same way in which the Rennaissance painters came by theirs. Therefore the same aberrations should be discovered by the sleuth in the work of Titian.

Even if lacking in not making peace with humanity in its homely aspects, the school of Paris must survive for its quality of search.

In this regard it is parrallel with the scepticism of Plato, or liberalism for that matter.

Human nature is so constituted that it venerates scepticism as well as faith and accords honor to the conqueror and martyr both.

The vitality of the movement is attested to by the antagonism it has evoked —the history of every surviving revolution

Child, madman, artist

10. Oskar Pfister (1873–1956), Swiss psychoanalyst, member, with Jung, Bleuler, and others, of the Zürich school of psychoanalysis. Author of the books *Expressionism in Art: Its Psychological and Biological Basis* (New York, 1923) and *Psycho-analysis in the Service of Education, being an Introduction to Psycho-analysis* (London: H. Kimpton, 1922).

The appearance of their work is similar.

Is the child mad, the madman childish, and does Picasso try to be a little of both.

All of them employ the basic elements of speech.

The child by the inner necessity of a vivid statement to be immediately realized, hence employing the most *instinctive* representation thru instinctive, primitive elementary symbols.

The madman by his symbolism.

The artist having analyzed his problem thru to these basic elements of plastic shapes and emotional symbols.

Cezanne and his followers pointed the way because they alone left the scaffaclding while[11]

Color

may be sensuous or functional.

Tonality implies a romantic control.

Pictorial function of a color involves aggressions advancing or regressions coming forward or going back

Can be accomplished either by color (warm o cold) or values.

Color may be exist for its own sake for

Lushness (orientalism)

Pattern (Rythmic impulse)

Strident Vividness (exhibitionism)

Spotting (decadent gourmandism

concious precociousness)

Design

A child learns to use the plastic tongue as easily and naturally as he uses word speech.

The scale conception involves the relationship of objects to their surroundings—the emphasis of things *or* space.

It definitely involves a *space* emotion. A child may limit space arbitrarily and then heroify his objects. Or he may infinitize space, dwarfing the importance of objects, causing them to merge and become a part of the space world. There may be a perfectly balanced relationship between the two. Pierro de la Francesco, where both participate equally in an imperical world, one augmenting the dignity of the other, denoting equal veneration for man, the things he has wrought, and his possessions.

11. Sentence is unfinished in source.

Freedom implies also another diversity: Decorativeness: as well as austerity. Lushness vs. acridity. Gollubriousness[12] vs. alacrity.

Defined areas, or a merging or a flux.

Sharp silhouette or indefinite merging

Painting around or modelling into the color.

The first would imply classical, intellectual objective, tendencies.

The second first would imply an emotional expressionistic objective tendency.

Eg: Francesca versus The Venitians

Greco

Abstractionists versus expressionists

The materials used are suited to these expression.

Analysis of whether means create styles or whether the style creates the invention of means. Both probably accurate.

Movement.

The mistaken notion that physical vigor implies action. It implies nothing but that the person who practices it is wields the brush vigorously.

Movement it is not dependent on the extent of *"distance"* (illusory) which is indicated in the picture.

A limited space and limited objects are more likely to express action and a communicable experience of movement.

Scale.

The difference between the appearance of freedom by the suggestion of a sweeping or rythmic manner and the true meaning of freedom which involves the development of a particular scale expressive of the relationship of things to things. This is inherent in a child.

Freedom can manifest itself thru tightness as well as exhuberance, thru fixation on detail as well as large massed areas.

It can involve an emphasis on *things* as well as on effects. It can be objective and analytic as well as romantic.

Assume

The right number of inhibitions or suppressions to provide the leaven, just right disturbance of equilibrium, to embue that excitement, that right exhaltation of spirit which demonstrates the difference between dynamic organism and static machination.

Liberalism rejects the unity which it cannot arrive at thru its technic of

12. This word is not easily decipherable.

scepticism. It will not accept a unity from the sheer conviction of the necessity of such acceptance. Lacking a myth it will not construct of moluch to lie down & worship.

Sensationalism versus constructivism

Sensationalism as such, or as an objective element equally sharing its place with other elements

The necessity of an impirical inquiry instead of vague enthusiasms.

The lack of it accounts for the end of the creative period and the influence of the high school teacher or some tradition.

We cannot teach a tradition today.

The progressive school is a symbol of liberalism.

It is the courage of liberalism to make a positive virtue of scepticism and inquiry and to draw no conclusion until the facts warrant it

Relationship of modern painters to children's work.

At the moment of *lay* art, when men discarded the myths and the methods developed to describe them, the artist looked into himself and found himself using his own emphasis (emotional) rather than visual, and using the geometric shapes.

Child uses simple geometric shapes eg. circle for a head.

Children invariably admire skill & photographic accuracy in exhibitions.

Kunkel

Kunkel: "We must never break the courage of children."[13]

Psychoanalysis in the Service of Education.

Pfister: Y.E.M. p. 70

The return to the past comes about regularly even in the conscious life. Jesus told men to become as little children. The rennaissance went back to antiquity for the purpose of going forwards. The reformation in the terrible distress of its times, attempted to introduce the Christianity of the first five centuries. The word reformation bears its own meaning on the surface. Rousseau preached the "return to nature" Tolstoi, the revolutionary innovator did actually go back to the primitive life. Without such retrogressions no great progressions are possible, and no fresh creation, however cleverly imagined, has any prospect of a future unless it has borrowed from the past. For it is wrecked on a law of spiritual life—".[14]

After the kindergarten the childs intention is representative— lengthy explanations.

13. Fritz Kunkel (1889–1956), German psychologist, emigrated to the United States during World War II. He was a disciple of Alfred Adler and later of Carl-Gustav Jung.
14. Rothko cites Pfister, *Psycho-analysis in the Service of Education* (London: H. Kimpton, 1922), 64–65.

The essentially *representative* tendency in art.

Being with artist & teacher:
The difference between a school and personal expression
Picasso vs. Chagall
Mozart sings like a bird
Beethoven revises and perfects
Yet both are perfect. The artist himself cannot be used as a criterion
Kant illustrates a perfect system with examples which time has relegated
Nietzsche & Greek tragedy.
Painters & poets might say just write or paint yet their work is
perfectly ordered.

Confusion between basic elements which are present in child's work &
that of modern artist.
In a child purely expressive & instinctive,
in the artist elements which are conciously used and ordered, Children,
however, who have returned from high school find work there easy but dull.
easy because they are accustomed to interests in methods
eg: textures
dull because creative, emotional emphasis is eliminated.
If we had a tradition upon which agreed we could teach it to our children:
You can paint this and that in such a way. So has experience & wisdom proved.
But that is not the case. That is why we find our academy boys with their brown
saucy pasts appearing bright hued among Our abstractionist shows, emotionally
gyrating among the expressionists.
Progressive education is the expression of liberalism.

Sketchbook, ca. 1934

Ten years ago, when this school began to function progressive art methods were looked upon us as a suspicious innovation and experiment. Today this method needs no martyrs. The method has extended itself into various public school buildings, which have become distinguished and admittance sought after for this very reason. It has even been extended into the teaching of adults.

This has been due to several reasons. First of all, an increased knowledge and appreciation by the public of art in general and contemporary art currents specifically, and also a widespread interest in the art of children by museums, galleries and other cultural centers who have been frequently exhibiting the work of children of working [?] from this point of view in our school and others schools. The public has responded to the new art and participated in the irresistible vividness and expressiveness of children's painting.[15] They have learned the difference between sheer skill and skill that is linked to spirit, expressiveness and personality, between the painter who paints well and the artist whose works breathe life and imagination, use materials to say something.

The difference between our methods and older methods is this. In the older methods a child was taught how to do various things. Given examples, his problem was to perfect himself in the imitation of them. The sum total of his experience was the sum of the things he learned to imitate and their combinations. In our methods the child from the very beginning is encouraged to be an artist, a creator. Our dictum is not to do so and so; but what would you like to express and how clearly and vividly can you express it. The result is a constant creative activity in which the child creates an entire childlike cosmology which expresses the

National Gallery of Art, Washington, D.C.

15. "They have learned the difference between sheer skill and skill that is linked to spirit, expressiveness and personality. . . . Between the painter who paints well and the artist whose works breathe life and imagination use materials to say something." Written in the margins.

infinitely varied and exciting world of a child's fancies and experience. School books, far off lands, movies, dreams, playgrounds, desires all contribute to the panorama of his work.

From the very beginning then, our children's work is art since it expresses in vivid terms the personality of our children. Do these children progress, improve, and how do they do it. Yes, they definitely progress. No two groups work on the same level. The level of observation and representation rises with each group and each age level. It happens this way. As they grow older their standards of observation rise as well as their experience with their art materials. To meet these new standards they must constantly deal with new problems and new methods.

Our children have courage. For instance if the Brooklyn Bridge fascinates them, they will draw it, and if it must extend across the river, they will make it do so.

In the old methods the child would have been stumped before he began. He would have been so aware of nature technics as difficult problems that this difficulty would have discouraged him from the very beginning. Our children working from the point of view of expressing their ideas, meet their problems as they feel the need for them as their standards of maturity demand.

The Ten: Whitney Dissenters, 1938

A new academy is playing the old comedy of attempting to create something by naming it. Apparently the effort enjoys a certain popular success, since the public is beginning to recognize an "American Art" that is determined by non-aesthetic standards—geographical, ethnical, moral or narrative—depending upon the various lexicographers who bestow the term. In this battle of words the symbol of the silo is in ascendancy in our Whitney museums of modern American art. The TEN remind us that the nomenclature is arbitrary and narrow.

For four years THE TEN have been exhibiting as an articulate entity; their work has been shown at the Montross Gallery, The New School for Social Research, Georgette Passedoit, the Municipal Gallery and at the Galerie Bonaparte in Paris. They have been called expressionist, radical, cubist and experimentalist. Actually, they are experimenters by the very nature of their approach, and, consequently, strongly individualistic. Their association has arisen from this community of purpose rather than from any superficial similarity in their work. As a group they are homogeneous in their consistent opposition to conservatism, in their capacity to see objects and events as though for the first time, free from the accretions of habit and divorced from the conventions of a thousand years of painting. They are heterogeneous in their diverse intellectual and emotional interpretations of the environment.

A public which has had "contemporary American art" dogmatically defined for it by museums as a representational art preoccupied with local color has a conception of an art only provincially American and contemporary only in the strictly chronological sense. This is aggravated by a curiously restricted chauvinism which condemns the occasional influence of the cubist and abstrac-

Exhibition leaflet. New York: Mercury Galleries, 1938. This text is not signed by Rothko in the catalogue, but Breslin (*Mark Rothko*, 582, n. 75) points out that Rothko (still listed as Rothkowitz) has been cited as a coauthor, with Bernard Braddon and Sidney Schectman.

tionist innovators while accepting or ignoring the obvious imitations of Titian, Degas, Breughel and Chardin.

The title of this exhibition is designed to call attention to a significant section of art being produced in America. Its implications are intended to go beyond one museum and beyond one particular group of dissenters. It is a protest against the reputed equivalence of American painting and literal painting.

"A comparative analysis," ca. 1941

A comparative analysis of the basic plastic elements, styles, and processes common to both the creative paintings of children and traditional art; and the application of this knowledge to the supervision of the creative art activity.

Mark Rothko,
Art Supervisor,
Center Academy
667 Eastern Parkway,
Brooklyn, N.Y.

29 East 28th St.
New York City

PART I

A comparative study of the basic plastic elements in the creative painting of children and those of traditional art, by definition and demonstration.

A. The similarity in appearance and aesthetic effect of the work of children, primitive races, the insane, and instances of "Modern Painting."
 1. The common factors in both which contribute to this similarity.

B. The detection of analogous factor in traditional art.

Three-page outline for a long essay or short book comparing the basic plastic elements, styles, and processes common to the creative paintings of children and to traditional art. Rothko's papers. Only a dozen or so pages of drafts remain of this text. There is a strong tie between this text and the "Scribble Book." Breslin affirms that, in fact, the "Scribble Book" was a preparation for this comparative analysis (see the footnote on page 18, this volume). Rothko lived at the address indicated in this outline between 1941 and 1943.

1. The study of both similarities and dissimilarities and the factors which explain them.

C. The definition and recognition of the plastic elements, their use, and their communicated effect.

 1. Kinds of shapes and what they represent or symbolize.

 2. Types of space and how they are achieved.

 3. Scale: size of objects in relation to the enclosing space, and psychological effect of its varied use.

 4. Line

 a. As the definition of shapes.

 b. Its abstract function in the achievement of various types of space.

 c. Its function in design.

 d. Its character.

 5. Color

 a. Its objective or subjective use.

 b. Its decorative use.

 c. Sensuous use.

 6. Textures: sensuous, decorative or representational.

 7. Rhythm, or repetition.

 8. Arrangement

 a. Classical

 b. Emotional

 c. Its function in the arabesque or spacial composition.

D. "Spontaneous," or untaught elements which appear in the work of all children, and kindred devices in traditional art.

E. A comparative analysis of methods and the techniques.

 1. The relation between the materials and methods.

 2. The relation between method and effect.

 3. The approximation of methods used unconsciously by the child to those contrived by traditional art.

F. The subject material and its sources.

G. Paintings and their relation to the character and background of the artist.

PART II

A comparative analysis of "style" in the work of children and in traditional art

A. The NATURAL PROCLIVITY of the child for some of the above elements: the Style which his selection and emphasis of a number of these imparts to his painting, distinguishing it from the paintings of every other child.

B. The study of various combinations of elements and the differences in style which they produce.

C. The analogous nature of style in traditional art.

D. Analogies between children's and traditional styles.

E. The INTEGRITY OF STYLE
 1. The subordinate position of subject to style: the demonstration that style is constant no matter what subject is used.

PART III

The Natural Proclivity principle as the basis of the creative art education

A. Its importance in the creativity of the art experience.
 1. The study of the factors which constitute creativity in both children's and traditional art.
 2. The difference between creative traditional art and academicism.
 3. The difference between the creative and what simply appears childlike.
 4. The distinction between creative painting and deliberate primitivism.
 5. The distinction between creative or inventive freedom and physical freedom in painting.

B. The teacher's role in the early creative stages of the child.
 1. Manipulative—
 a. Avoidance of physical and emotional inhibitions.
 2. The period of natural uninhibited expression
 a. Necessity of genuine reaction to the child's work.
 b. The *recognition of natural proclivity of each child.*
 3. Period of self consciousness and the beginning of learning.
 a. The continuance of creativity through the resolution of difficulties in the terms of the natural proclivity of the child, and its importance to future continuation of the activity.

C. The preservations of the natural proclivity in later stages
 1. In drawing or paintings from life
 2. In the development of imaginative painting.

PART IV

The philosophical basis of the creative art experience in education.

A. An historical analysis of art teaching methods

B. The pertinence of the creative method in our own day
 1. In relation to the personality adjustment of the child.
 2. In relation to his ultimate participation, either active or passive, in the cultural life of society.

Laboratory experimentation for the Teacher

A. Creative painting
 1. The self-inducement of creative states through the elimination of physical and emotional inhibitions by the painting of imaginative pictures.
 2. The recognition of the plastic elements in the paintings produced.
 3. The recognition in this work [of] the natural proclivity for a certain kind of style.
 4. The exploitation of this style in a series of planned variations.
 5. The execution of different styles by a deliberate use of other combinations of elements.

B. The extension of style in drawing and painting from life.

C. The study of methods and techniques relating to those used by children.
 1. The preparation of different surfaces and the study of effects characteristic of each.
 2. The study of pigments and their function in different techniques.
 3. The simulation of styles characteristic of different materials.
 4. The exploitation of materials for new effects in their own paintings.

"The ideal teacher," ca. 1941

The ideal teacher in charge of the creative art activity must possess a twofold equipment. First, in common with every teacher he has the insight and training to evaluate the character, background and potentialities of the child; his very presence and manner create an atmosphere of ease and confidence; and he shares the general idea of social adjustment of the educational process of which this activity is a part. Secondly, and this is really the important qualification in this study, he must possess the sensibility of an artist. Art must be to him a language of lucid speech inducing the understanding and exaltation which art properly inspires. It is the artist teacher who has fulfilled that role with the most frequent success. Because art is his own best mode of expression, and because of his intimate relationship with it and its methods, both in his own expression and that of other artists both past and present, he is likely to have developed that sensibility to a higher degree than others whose only contact with art is from the point of view of the observer. This sensibility becomes an important element in his effect upon the child's creativity. In younger children where he must abstain completely from an interference with the creative process except in the correction of mere manipulative immaturity, this will enable him to react with sincere enthusiasm to what the child has done. He will be able to understand the most obscure symbol, the most faintly suggested idea, to understand every simile, conceit and the thousand other unpredictable manifestations of plastic creativity, and to enable him to make the child aware of his reaction. This reaction must be honest for simulation is soon detected. This appreciation really makes of the teacher a co-creator. Thus it is our wish to retain the natural direction of expression. It is really the consummation of the picture for it establishes to the child the necessary communicability of his picture which completes the process and provides the confidence for the next. At the age of eight or nine when the growing impact of environment induces

Section draft of "A comparative analysis." Rothko's papers.

a self-consciousness and questions begin to be asked. The child can no longer be left completely alone. These questions must be resolved. Then the responsibility is a more serious one. This sensibility must be able to enter the child's creative world, to discover its peculiarities and proclivities and to base its answers upon these grounds. These answers must not introduce elements foreign to the child's creative constitution, for they would shock his sense of security and greatly endanger the continuance of his creative integrity.

Today this sensibility is a very inconstant quantity never being equal in any two persons. Nor do standards exist whereby we may even roughly gage its extent or its kind. We indeed must trust upon a metaphysical intuition. How catholic are the scope of this person's sensibilities. To what extent do strong personal aesthetic prejudices destroy their objectivity and hence their usefulness to us. Just how much does he know and how does that compare with what he should know, and then what should he know. Why in our form of education are those prejudices undesirable.

It is not the purpose of this book to eliminate this sensibility, for a reaction to art based on knowledge alone would fail in essential reaction. It is however our purpose to augment this sensibility with a body of demonstrable knowledge, and thereby eliminate certain inadequacies in our results, which by now we must have the courage to admit.

1. That the period of creativity is usually lost before the child reaches the age of 12 and often earlier.
2. That often after the age of nine a primitivism is substituted for creativity, whose only virtue is its resemblance of child's but which in truth is no longer creative. It is simply a mimicry of creative work.
3. That it has not been successfully resolved to take its place in the terms of future development.

It is in the hope of pointing a way to the solution of these difficulties that the author has studied the work of children and has analyzed and will present them in the pages to follow.

The following careful study has been made with the hope of adding something to our present scant knowledge of the numerous factors in the child's creative painting. It hopes to present a logical system which will augment this less tangible and invaluable tangibility, and it stems that in knowledge lies the answer to many of our difficulties.

This analysis rests on a series of assumptions. We believe those to be

true and demonstrable and will rest our conclusions by using the actual work of children as the basis of discussion.

That a close analogy exists between the crative [*sic*] art work of child and the works that are accepted by common consent as works of art. That the child employs instinctively or consciously or thru some imperceptible experience of his infancy the same basic elements of plastic speech which are to be found in the works of the masters. An analysis and a series of comparisons will form the first part of the knowledge which we wish to establish. This task has been somewhat facilitated by the existence of modern art.

"Indigenousness," ca. 1941

The entire problem of art education concerns itself with the objectives of that education. We have already established that the whole process of painting is a biological activity involving the expression of the creative impulse and that painting is one of the natural languages which exist for the performance of this function. This is attested to by the natural ease with which the child seems to create the essential forms which are constantly present in all art. To deny the child that experience would be to thwart a means of speech and communication as instinctive as speech itself.

Once included in our school curriculum we must, however, concern ourselves with the objectives of this activity. These objectives are of two types:

1. Their contribution to the child in their immediate sense, as an exercise of expression during his school life.
2. Their contributions to his adulthood and finally in the pattern of his existence.

In relation to the first, the creative painting activity has already adequately proved its value in the practice it has received in our progressive schools. First, it has contributed to the happiness of the child, for here he has found an activity which he delights in performing. The fact that his results have the quality which they undoubtedly do, the fact that he is able to produce an overt manifestation of something that is so vivid to him, and so instinctive, and that he has been able to communicate it, has a salutary effect on his personality adjustment. That it has a tendency to help in a dispersion of inhibitions and a definite aid to his personality adjustment can be readily perceived.

Now we must consider the second objective. Unless we consider the creative painting experience in the same category as we consider building blocks

Section draft of "A comparative analysis." Rothko's papers.

or mud pies—simply a play function in relation to plastic materials which we can drop when the interests of the child no longer demand them. Obviously the painting activity cannot be considered in those terms, for painting forms a very important part in the adult life of society, as sooner or later the child will in some measure participate in the cultural aspects of society in which painting plays an important part. Therefore this instinctive activity must be concerned with ulterior objectives of the child's ultimate participation in the cultural life, in either active or passive form. The distinction between the two is not so wide as might be supposed, because a satisfactory passive participation is in its own way as creative as the painting of pictures itself.

The natural, completely uninhibited, activity sustains itself for a comparatively brief period. Sooner or later we shall be confronted by the fact that the child is no longer content to work unconsciously. He wants the pleasures of learning, development and progress. In the case of some children that progress may take place of itself, but it will be more generally be true [sic] that the teacher or the environment will have to take a hand in the gratification of this learning desire. Once we have arrived at this stage we must gravely consider the seriousness of our responsibility. We must point a direction which is at least not contradictory but contributive to the possible future experience of the child.

Obviously, the importance of the personal adjustment elements in the immediate life of the child are the most important during the period of education. Yet this book proceeds from the premise that the adjustment can take place without the violation of the laws of painting itself; and that the proper consideration of those laws will contribute most materially to the attainment of the first objectives as well as the second.

We cannot but look with envy at the certainty with which art teaching could be practiced in some of the great art periods of the past. The apprentice who entered the studio of the masters of the Renaissance was fortunate indeed. For the objectives as well as the methods of the art were pretty clearly defined and quite generally accepted. That this implies a certain sort of dogmatism is well compensated by the fact that this dogmatism did in the end produce an art which was vital in its own day and whose worth time has not diminished for us. Fortunately, such was the unity of those times, and so adequate the synthesis for the intellectual and spiritual needs of those ages, that the development of art could proceed within the frame work of the established order.

Unfortunately our own society has not evolved a comparable unity either in relation to its ideas or to its art. Our own country is today a bloodless battlefield where a dozen conflicting or unrelated attitudes are in the struggle for acceptance.

The different attitudes have each their own audiences varying widely in size. We have not a myth which to us today is sufficiently axiomatic and recognizable which art can employ for the purposes of generally acceptable symbols. In this country, particularly, we have not even a clearly tried artistic tradition evolved indigenously over a sufficiently long period which gives us a scale for satisfactory methods and purposes.

It would be interesting indeed to make a survey of the students of the national academy who are supposedly the keepers of the avowed American tradition and study the history of their students. We shall find a certain number who have made the painting of fashionable portraits adhering to the precepts of the academy. It will be very surprising however to discover that a vast majority have revolved against their tradition and how many of them will be found exhibiting with abstract groups, expressionist and the new American group, none of whom are the logical employment of the precepts taught by the academy.

"The satisfaction of the creative impulse," ca. 1941

The satisfaction of the creative impulse is a basic, biological need, essential to the health of the individual. Its aggregate effect on the health of society is inestimable. Art is one of the few important means known to man for the articulation of this impulse. This is why its practice is as continuous as life itself. It has survived every proscription by man made law or custom, and every difficulty which nature contrived in the intractability of its materials, no matter how unyielding the surface or how adverse the circumstance, man has persisted in this recording of his imaginings. The process itself is a psychological parallel inevitable to all biological processes. Man receives and therefore must expel. The alternative is strangulation. Man's senses collect and accumulate, the emotions and mind convert and order, and through the medium of art, they are emitted to participate again in the life stream where in turn they *will* stimulate action in other men. For art is not only expressive but communicable as well, this communicability imparts to it a social function.

The writer will state then this inevitable conviction; that the practice of art is a social action, intrinsically important, requiring no auxiliary justifications. Its conclusion, therefore, in the educational curriculum needs no apology.

If the making of art or artists were the aim of education, we could simply hang an exhibit of the child's creative work and stop there. For no one, to whom the language of forms and colors speaks at all, can remain unmoved by the panorama of children's art that has been accumulated by this time. They are a compelling, moving artistic expression, which have provided an intrinsic addition to the cultural heritage of our society. However, education is not concerned with the making of artists as an end. It no more predicts that the child who paints will be an artist than that the one who adds and subtracts will be a mathematician. It can intend this, however: that this early experience will be a contributing incor-

Section draft of "A comparative analysis." Rothko's papers.

porable factor in the ultimate development rather than a contradictory one which must be effaced—a difficult process indeed.

For the educator, art, then, must have many implications beyond itself. It must contribute to the child's social attitude, psychological stability, the formation of proper habits and a host of additional orientations towards environment essential to his development as a social individual.

If these considerations are omitted from this book, it is not because their importance is underestimated. We shall restrict ourselves here, insofar as possible, to a consideration of the subject from the point of view of art itself. All the ends stated above can best be served by our first understanding the subject itself in the spirit of utmost integrity to its own laws. There may be exceptions in the cases of abnormality, where a temporary white lie may be prescribed as a temporary therapeutic expedient.

It will be our assumption, too, that the child is a normal child, that his heritage has well equipped him with the help of our understanding to cope with the serrated demonology which lurks to trap him. That he has just the right number of inhibitions or repressions to imbue him with that catalytic le[a]ven, with that necessary instability of equilibrium, to impel him to a series of actions of which painting will be one.

Manuscript drafts of a letter to the editor by Rothko and Adolph Gottlieb, 1943

DRAFT 1

Dear Mr. Jewel:

I was glad to observe that your remarks concerning my painting at the exhibition of Modern Painters & Sculptors seemed couched in the form of a question rather with the hostility which has usually attended your reviews of my work. This being so, I would like to try to explain myself to you and I hope that you can print this explanation, since you have raised the question publicly.

What you are [illegible] my work is simply another aspect of the preoccupation with the archaic.

Why the most gifted painters of our time should be preoccupied with the forms of the archaic and the myths from which they have stemmed, why negro

The letter was published in the *New York Times* on June 13, 1943. Mark Rothko, Manuscripts and Sketchbook, ca. 1935–1943; acc. no. 2002.M.8 (box 3). Research Library, Getty Research Institute, Los Angeles. Rothko exhibited *The Syrian Bull* and Gottlieb *The Rape of Persephone* at the Federation of Modern Painters and Sculptors. These two works had been the subject of criticism by Edward Alden Jewell, a journalist for the *Times*, in response to which Rothko and Gottlieb wrote this letter. This text, as yet unpublished, was written by Rothko before Gottlieb and he decided to send a letter together. This version clearly differs from the final text: the drafts reflect a less dogmatic tone. They are not paginated. Rothko simply makes notes, in six stages. These drafts are preserved in the collection of Georges C. Carson, a relative of Rothko's first wife, Edith Sachar Carson. They were recently acquired by the Getty Museum. Barnett Newman collaborated equally in the writing of the letter that eventually appeared in the *Times*. To thank him for his help, Rothko and Gottlieb offered him the two paintings mentioned as objects of criticism by Jewell. See Diane Waldman, *Mark Rothko, 1903–1970: A Retrospective* (New York: Harry N. Abrams, 1978), 269. In an interview of 1953 with William Seitz, Rothko said that neither he nor Gottlieb had written the letter that appeared in the *Times* but that he was in complete agreement with its contents (see p. 85, this volume). This testimony underscores the importance of the drafts, which are truer to Rothko's thought, although the text of the published letter is a central part of the quasi-totality of Rothko studies. See Bonnie Clearwater, "Shared Myths: Reconsiderations of Rothko's and Gottlieb's letter to the *New York Times*," *Archives of American Art* 24, no. 1 (1984): 23.

sculpture and archaic Greek should have been such potent catalyzers of our present day art, we can leave to historians and psychologists. But the fact remains that our age [is] distinguished by its distortions, and everywhere the gifted men whether they seat the model in their studio or seek the form within themselves, all have distorted the present to conform with the forms of Nineveh, the Nile or the Mesopotamian plane. That the public at large still finds the bulk of modern art ugly, savage, unreal attests to that commonness to Modern Art. To say that the modern artist has been fascinated by the formal aspects of archaic art is not tenable. Any serious artist will agree that a form is significant so far as it is expressive of that noble and austere formality which those archaic things possess. We must therefore [say] that the art of today feels a close kinship with the formal-psychological aspects which these archaic things posses. To rale that our art is therefore not of our time is to deny that art is timeless, and that we know that it is that art which illustrates the moment is no longer relevant in the next, since the moment has passed. To rale at this art that it is illogical and immeasurable is about as effective as railing at the complete materialism of our every day life. My own art is a new aspect of the same myth, and I am neither the first nor the last compelled irretrievably to deal with the chimeras that seem the most profound message of our own time.

In naming my picture the Syrian Bull, I was helping the onlooker by naming an association with the art of the past, which once my picture was done, I could not but observe.

It is strange altho' no longer new that art should persist in evolving these chimeras, these unreasonable distortions, this outward savagery & apparent ugliness and brutality. But strange or not the gifted men of our time have all persisted in this barbarism & will continue to do so until the aspects of our civilization change, when I do not know. Our art seems inevitably to stem from African fetishes, and the archaic visions of the Aegean sea, & Mesopotamian plane, the fetishes of a bygone day which our reason would banish as superstitions no longer tenable within our time. I am therefore neither the first nor last painter of our day who will continue to reveal new aspects of these timeless myths. And the critic and sociologist still continues to rail against that which by this time should have impressed itself upon him as inevitable: For it is just as ineffectual to rail against this as it is to rail against the excessive materialism of our every day life. He must accept that these are spiritual faces of our day.

Perhaps the artist was a prophet and many decades ago discovered the unpredictability which lay under man's seemingly ascending reason, & he saw the

potentiality for carnage which we know too well today. But why press home this point. The artist paints and what he must.

There are still artists who still confound sunset and long shadows; the melancholy aspects of the times of day with the tragic concepts with what art must deal; but in all the art which jolts, moves and instigates to new discoveries is the art which distorts.

DRAFT 2

Any one familiar with the evolution of modern art knows what potent catalyzers of negro sculpture, and the art of the Aegean were at its inception. And since this inception the most gifted men of our time, whether they seated their models in their studio, or found within themselves the models for their art, have distorted these models until they awore[16] the traces of their archaic prototypes and it is this distortion which symbolizes the spiritual face of our time.

To say that the modern artist has been fascinated primarily by the formal relationship aspects of archaic art is, at best, a partial and misleading explanation. For any serious artist and thinker will know that a form is significant only insofar as it expresses the inherent idea. The trick is therefore that the modern artist has a spiritual kinship with the emotions which these archaic forms imprison and the myths which they represent. The public, therefore, which reacted so violently, so violently to the primitive brutality of this art reacted more accurately truly than the critic who spoke about forms and techniques. That the public resented this spiritual mirroring of itself is not different to understand.

To say that our art is not of our time, is to deny that art is timeless, and to deny that the art which speaks for the moment is no longer relevant as art once that moment has passed. To rale at this art that it is illogical and unreasonable is about as effective as railing against the excessive materialism of our every day life. Both will continue relentlessly and inevitably. My own art is simply a new aspect of the eternally archaic myth, and I am neither the first nor will be the last compelled to evolve these chimeras of our time. Unfortunately, the critic is historically a dealer in the familiar, and the unfamiliarity of new aspects, makes it necessary for us to create without his assent.

DRAFT 3

The affinities between modern art and the archaic are to[o] obvious to need proof.

16. This word is difficult to decipher.

That the birth of this art should so often recall either the forms of the spirit of negro Sculpture and archaic Aegean —too persistent to be accident and to[o] unremunerative to be affectation. Nearly all of the gifted artists of our generation whether they have studied the model in their studios or have found their models within themselves,[17] have distorted them until they have approached the spirit of this ideal prototype. Is it strange that we persist in evolving this chimeras, these unreasonable distortions, these barbarism of a distant past? For those who must have rational explanations, the idea has been formulated that this art possesses formal qualities which we find useful. For myself I cannot accept anything so incomplete. We should never have been struck by this formal quality, were it not expressive of a spirit with which we possess our ineffable kinship.

The world is what the artist makes it.

DRAFT 4

The face of modern art resembles closely its archaic prototype. It is no trade secret that our past, negro sculpture, and the archaic art of the Aegean have been the potent catalyzers of our present day art. And most of our gifted, everywhere, whether they have seated their models in their studios, or have found them within themselves, have distorted the present to conform with the forms of Nineveh, the Nile of the Mesopotamian plane.

DRAFT 5

We deny that the world of art has any objective appearance. The world is what the artist makes it.

We deny that for art the world of objective appearance has any precedence over the world of hallucinations.

We liked the violence of the reaction, whether in praise or disdain, because to us it was a proof that the picture struck home.

DRAFT 6

1. We deny that the world has any objective appearance, the world is what the artist makes it.
2. And in this world the eye is only an element of the totality of experience, has no precedence over feelings and thoughts.

17. The phrase "models within themselves" is stricken from the text, but because it is necessary syntactically and is a trope common to other drafts, I have retained it here.

3. reason has no precedence over unreason, the paradox, hyperbole, hallucination, etc.[18]

#6 A picture is not its color, its form, or its anecdote, but an intent entity idea, where implications transcend any of these parts.

We do not strain to be either obvious or obscure, but to state our intent, rather, as directly and simply as we can.

18. A calligraphic flourish occupies a large, otherwise empty space in the manuscript here, perhaps explaining in part the jump from 3 to 6 in the list.

Rothko and Gottlieb's letter to the editor, 1943

Mr. Edward Alden Jewel
June 7, 1943
Art Editor, New York Times
229 West 43 Street
New York, N.Y

Dear Mr. Jewell:

To the artist, the working of the critical mind is one of the life's mysteries. That is why, we suppose, the artist's complaint that he is misunderstood, especially by the critic, has become a noisy commonplace. It is therefore, an event when the worm turns and the critic of the TIMES quietly yet publicly confesses his "befuddlement," that he is "non-plussed" before our pictures at the Federation Show. We salute this honest, we might say cordial reaction towards our "obscure" paintings, for in other critical quarters we seem to have created a bedlam of hysteria. And we appreciate the gracious opportunity that is being offered us to present our views.

We do not intend to defend our pictures. They make their own defense. We consider them clear statements. Your failure to dismiss or disparage them is a prima facie evidence that they carry some communicative power.

We refuse to defend them not because we cannot. It is easy matter to explain to the befuddled that "The Rape of Persephone" is a poetic expression of the essence of the myth; the representation of the concept of seed and its earth with all its brutal implications; the impact of elemental truth. Would you have us present this abstract concept with all its complicated feelings by means of a boy and girl lightly tripping?

It is just as easy to explain "The Syrian Bull" as a new interpretation of an archaic image, involving unprecedented distortions. Since art is timeless, the

Mark Rothko, Manuscripts and Sketchbook, circa 1935–1943, acc. no. 2002.M.8, box 3. Research Library, Getty Research Institute, Los Angeles. Letter published in its entirety in Edward Alden Jewell, "The Realm of Art: A New Platform and Other Matters," *New York Times*, June 13, 1943, sec. 2, X9.

significant rendition of a symbol, no matter how archaic, has as full validity today as the archaic symbol had then. Or is the one 3000 years old truer?

But these easy program notes can help only the simple-minded. No possible set of notes can explain our paintings. Their explanation must come out of a consummated experience between picture and onlooker. The appreciation of art is a true marriage of minds. And in art, as in marriage, lack of consummation is ground for annulment.

The point at issue, it seems to us, is not an "explanation" of the paintings but whether the intrinsic ideas carried within the frames of these pictures have significance.

We feel that our pictures demonstrate our aesthetics beliefs, some of which we, therefore, list:

1. To us art is an adventure into an unknown world, which can be explored only by those willing to take the risks.
2. This world of the imagination is fancy-free and violently opposed to common sense.
3. It is our function as artists to make the spectator see the world our way—not his way.
4. We favor the simple expression of the complex thought. We are for the large shape because it has the impact of the unequivocal. We wish to reassert the picture plane. We are for flat forms because they destroy illusion and reveal truth.
5. It is a widely accepted notion among painters that it does not matter what one paints as long as it is well painted. This is the essence of academicism. There is no such thing as good painting about nothing. We assert that the subject is crucial and only that subject matter is valid which is tragic and timeless. That is why we profess spiritual kinship with primitive and archaic art.

Consequently if our work embodies these beliefs, it must insult anyone who is spiritually attuned to interior decoration; pictures for the home; pictures for over the mantel; pictures of the American scene; social pictures; purity in art: prize-winning potboilers; the National Academy; The Whitney Academy, the Corn Belt Academy; buckeyes; trite tripe; etc.

Sincerely yours,
Adolph Gottlieb
Marcus Rothko
130 Estate Street
Brooklyn, New York

"The Portrait and the Modern Artist," by Rothko and Adolph Gottlieb, October 13, 1943

ADOLPH GOTTLIEB: We would like to begin by reading part of a letter that has just come to us:

"The portrait has always been linked in my mind with a picture of a person. I was therefore surprised to see your paintings of mythological characters, with their abstract rendition, in a portrait show, and would therefore be very much interested in your answers to the following."

Now the questions that this correspondent asks are so typical and at the same time so crucial that we feel that in answering them we shall not only help a good many people who may be puzzled by our specific job but we shall best make clear our attitude as modern artists concerning the problem of the portrait, which happens to be the subject of today's talk. We shall therefore, read the four questions and attempt to answer them as adequately as we can in the short time we have.

Here they are:

1. Why do you consider these pictures to be portraits?
2. Why do you as a modern artist use mythological characters?
3. Are not these pictures really abstract paintings with literary titles?
4. Are you not denying modern art when you put so much emphasis on subject matter?

Now, Mr. Rothko, would you like to tackle the first question? Why do you consider these pictures to be portraits?

MR. ROTHKO: The word portrait cannot possibly have the same meaning for us that it had for past generations. The modern artist has, in varying degrees, detached

Broadcast on Radio WYNC, *Art in New York* program, October 13, 1943. Rothko's papers. Rothko and Gottlieb explained their aesthetic principles on the radio program, detailing the importance of myth and classical symbolism in their artistic work.

himself from appearance in nature, and therefore, a great many of the old words, which have been retained as nomenclature in art, have lost their old meaning. The still life of Braque and the landscapes of Lurcat have no more relationship to the conventional still life and the landscape than the double images of Picasso have to the traditional portrait. New Times! New Methods!

Even before the days of the camera there was a definite distinction between portraits which served as historical or family memorials and portraits that were works of art. Rembrandt knew the difference; for, once he insisted upon painting works of art, he lost all his patrons. Sargent, on the other hand, never succeeded in creating either a work of art or in losing a patron—for obvious reasons.

There is, however, a profound reason for the persistence of the word "portrait" because the real essence of the great portraiture of all time is the artist's eternal interest in the human figure, character and emotions—in short, in the human drama. That Rembrandt expressed it by posing a sitter is irrelevant. We do not know the sitter but we are intensely aware of the drama. The Archaic Greeks, on the other hand, used as their models the inner visions which they had of their gods. And in our day, our visions are the fulfillment of our own needs.

It must be noted that the great painters of the figure had this in common. Their portraits resemble each other far more than they recall the peculiarities of a particular model. In a sense they have painted one character in all their work. This is equally true of Rembrandt, the Greeks, or Modigliani, to pick someone closer to our own time. The Romans, on the other hand, whose portraits are facsimiles of appearance, never approached art at all. What is indicated here is that the artist's real model is an ideal which embraces all of human drama rather than the appearance of a particular individual.

Today the artist is no longer constrained by the limitation that all of man's experience is expressed by his outward appearance. Freed from the need of describing a particular person, the possibilities are endless. The whole of man's experience becomes his model, and in that sense it can be said that all of art is a portrait of an idea.

MR. GOTTLIEB: That last point cannot be overemphasized. Now, I'll take the second question and relieve you for a moment. The question reads, "Why do you as a modern artist use mythological characters?"

I think that anyone who looked carefully at my portrait of Oedipus, or at Mr. Rothko's Leda, will see that this is not mythology out of Bulfinch. The implications here have direct application to life, and if the presentation seems strange, one could without exaggeration make a similar comment on the life of our time.

What seems odd to me, is that our subject matter should be questioned, since there is so much precedent for it. Everyone knows that Grecian myths were frequently used by such diverse painters as Rubens, Titian, Veronese, and Velázquez, as well as by Renoir and Picasso more recently.

It may be said that these fabulous tales and fantastic legends are unintelligible and meaningless today, except to an anthropologist or student of myths. By the same token the use of any subject matter which is not perfectly explicit either in past or contemporary art might be considered obscure. Obviously this is not the case since the artistically literate person has no difficulty in grasping the meaning of Chinese, Egyptian, African, Eskimo, Early Christian, Archaic Greek, or even pre-historic art, even though he has but a slight acquaintance with the religious or superstitious beliefs of any of these peoples.

The reason for this is simple, that all genuine art forms utilize images that can be readily apprehended by anyone acquainted with the global language of art. That is why we use images that are directly communicable to all who accept art as the language of the spirit, but which appear as private symbols to those who wish to be provided with information or commentary.

And now, Mr. Rothko, you may take the next question. Are not these pictures really abstract paintings with literary titles?

MR. ROTHKO: Neither Mr. Gottlieb's paintings nor mine should be considered abstract paintings. It is not their intention either to create or to emphasize a formal color-space arrangement. They depart from natural representation only to intensify the expression of the subject implied in the title—not to dilute or efface it.

If our titles recall the known myths of antiquity, we have used them again because they are the eternal symbols upon which we must fall back to express basic psychological ideas. They are the symbols of the man's primitive fears and motivations, no matter in which land or what time, changing only in detail but never in substance, be they Greek, Aztec, Iceland, or Egyptian. And modern psychology finds them persisting still in our dreams, our vernacular, and our art, for all the changes in the outward conditions of life.

Our representation of these myths, however, must be in our own terms, which are at once more primitive and more modern than the myths themselves —more primitive because we seek the primeval and atavistic roots of the idea rather than the graceful classical version; more modern than the myths themselves because we must redescribe their implications through our own experience. Those who think that the world of today is more gentle and graceful than the primeval and predatory passions from which these myths spring, are either not aware of

reality or do not wish to see it in art. The Myth holds us, therefore, not thru its romantic flavour, not thru the remembrance of the beauty of some bygone age, not thru the possibilities of fantasy, but because it expresses to us something real and existing in ourselves, as it was to those who first stumbled upon the symbols to give them life

And now, Mr. Gottlieb, will you take the final question? Are you not denying modern art when you put so much emphasis on subject matter?

MR. GOTTLIEB: It is true that modern art has severely limited subject matter in order to exploit that technical aspects of painting. This has been done with great brilliance by a number of painters, carried far enough. The surrealists have asserted their belief in subject matter but to us it is not enough to illustrate dreams.

While modern art got its first impetus thru discovering the forms of primitive art, we feel that its true significance lies not merely in formal arrangements, but in the spiritual meaning underlying all archaic works.

That these demonic and brutal images fascinate us today, is not because they are exotic, nor do they make us nostalgic for a past which seems enchanting because of its remoteness. On the contrary, it is the immediacy of their images that draws us irresistibly to the fancies, the superstition, that fables of savages and the strange beliefs that were so vividly articulated by primitive man.

If we profess a kinship to the art of primitive man, it is because the feelings they expressed have a particular pertinence today. In times of violence, personal predilections for niceties of color and form seem irrelevant. All primitive expression reveals the constant awareness of powerful forces, the immediate presence of terror and fear, a recognition and acceptance of the brutality of the natural world as well as the eternal insecurity of life.

That these feelings are being experienced by many people thruout the world today is an unfortunate fact, and to us an art that glosses over or evades these feelings, is superficial or meaningless. That is why we insist on subject matter, a subject matter that embraces these feelings and permits them to be expressed.

Comments on *The Omen of the Eagle*, 1943

The theme here is derived from the Agamemnon Trilogy of Aeschylus. The picture deals not with the particular anecdote, but rather with the Spirit of Myth, which is generic to all myths at all times. It involves a pantheism in which man, bird, beast and tree—the known as well as the knowable—merge into a single tragic idea.

Reprinted from Sidney Janis, *Abstract and Surrealist Art in America* (New York: Reynal and Hitchcock, 1944), 118.

Brief autobiography, ca. 1945

Born Dvinsk, (Latvia) 1903; Migrated to Portland Oregon, 1913. Entered Yale as undergraduate 1921. My interests there divided between Labor economics, motivated by strong social sympathies; mathematics, for which I seemed to have a natural flair; and literature as an adolescent luxury. Abandoned my academic studies 1923 returned to Portland where I joined a small theatrical company. It was here I had my first contact with the world of design and color.

By 1926 I found myself in N.Y. a student of Max Weber at the art student's league. I remained there for three months.

Exhibited first at the Opportunity Gallery 1929, and held my first one man exhibition at the Contemporary Art Gallery in 1933. Joined the Secession Gallery in 1934, and was instrumental in forming the first group of Expressionist painters in America "The Ten", in which I exhibited for more than five years here and in Paris. The association with the artists in this group was an extremely stimulating factor in my development.

The last phase of this direction in my work was exhibited by J. B. Neuman in his galleries in 1939. Shortly thereafter, I became convinced of the limitations of that tendency for the expression of my whole equipment and predilections. I stopped painting and spent nearly a year developing both in writing and in studies my ideas concerning the Myth and anecdote which are the basis of my present work. This is the first comprehensive exhibition of this work.

Rothko's papers. This brief autobiographical presentation was, it seems, written by Rothko for his exhibition of January 9–February 4, 1945, at the gallery Art of This Century. Two versions exist, preserved by the Rothko family. I have reproduced the more complete one.

Letter to Emily Genauer, 1945

Mark Rothko
22 West 52nd St.
New York City
Jan. 15th, 1945
Miss Emily Genauer
World Telegram
New York City

Dear Miss Genauer—

Since I saw you at the opening of my exhibition at the Art of This Century, I was keenly disappointed not to read your opinion of it on Saturday. I simply wish to recall to you that the exhibition runs until February 4th, and that should you be able to find the space for it on some subsequent Saturday, it would make me very happy.

 Sincerely
 Mark Rothko

Emily Genauer papers, [ca. 1930–1995]. Archives of American Art, Smithsonian Institution, Washington, D.C. Genauer was an art critic and Pulitzer Prize–winning journalist for the *New York World*, the *Telegram*, and the *Sun*. Rothko wrote to her to request that she publish a review of the exhibition in which he was showing fifteen paintings, among them *The Syrian Bull, Birth of Cephalopods, Poised Elements*, and *Slow Swirl at the Edge of the Sea*.

"I adhere to the reality of things," 1945

I adhere to the reality of things and their substance.

I adhere to the reality of things and to the substantiveness of these things. In enlarging the extent of this reality I merely enlarge the extent of this reality, multiply the number of its denizens, and extend to them coequal attributes which I experience concerning the more familiar environment. I insist upon the equal existence of the world engendered in the mind and the world engendered by God outside of it. If I have abandoned the use of familiar objects it is because I refuse to mutilate their appearance for the rigors of a grace and life which they are too old to serve and for which perhaps they were never intended.

I quarrel with surrealist and abstract art only as one quarrels with his father and mother, recognizing the inevitability and function of my roots, and insistent upon my dissensions, I am both them and a new integral completely independent of them.

For me the surrealist has uncovered the glossary of the myth and has established a congruity phantasmagoria of the unconscious with the objects of everyday life. This is for me the exhilaration of tragic experience which is the only source book for art. But I love both the object and the dream far too much to have them effervesced into the insubstantiality of memory and hallucination.

Draft of a personal statement for the exhibition catalogue *Painting Prophecy, 1950*, David Porter Gallery, Rothko's papers.

Personal statement, 1945

I adhere to the material reality of the world and the substance of the things. I merely enlarge the extent of this reality, extending to it coequal attributes with experiences in our more familiar environment. I insist upon the equal existence of the world engendered in the mind and the world engendered by God outside of it. If I have faltered in the use of familiar objects, it is because I refuse to mutilate their appearance for the sake of an action which they are too old to serve: or for which, perhaps, they had never been intended.

I quarrel with surrealist and abstract art only as one quarrels with his father and mother recognizing the inevitability and function of my roots, but insistent upon my dissension; I, being both they, and an integral completely independent of them. The surrealist has uncovered the glossary of the myth and has established a congruity between the phantasmagoria of the unconscious and the objects of everyday life. This congruity constitutes the exhilarated tragic experience which for me is the only source book for art. But I love both the object and the dream far too much to have them effervesced into the insubstantiality of memory and hallucination. The abstract artist has given material existence to many unseen worlds and tempi. But I repudiate his denial of the anecdote just as I repudiate the denial of the material existence of the whole of reality. For art to me is as anecdote of the spirit, and the only means of making concrete the purpose of its varied quickness and stillness.

Rather be prodigal than niggardly, I would sooner confer anthropomorphic attributes upon a stone, than dehumanize the slightest possibility of consciousness.

Reprinted with permission from David Porter, *Personal Statement, Painting Prophecy, 1950* (Washington, D.C.: The Gallery Press, 1945), Porter's work focuses on the artists whom he believes embody a new trend in art: Baziotes, Stuart Davis, Jimmy Ernst, Gottlieb, Knaths, Pollock, Richard Pousette-Dart, and Rothko. Rothko wrote the text for the exhibition catalogue.

Letter to the editor, July 8, 1945

WRITINGS ON ART 1945

It seems to me that to make this discussion hinge upon whether we are moving closer to or further away from natural appearances is somewhat misleading, because I do not believe that the paintings under discussion are concerned with that problem. Some abstraction, such as cubism, leaned heavily upon natural appearances as starting point; others, such as purism, avoided any associations with real objects or their environment. But we are in a sense mythmakers and as such have no prejudices either for or against reality. Our paintings, like all myths, do not hesitate to combine shreds of reality with what is considered "unreal" and insist upon the validity of the merger.

If there are resemblances between archaic forms and our own symbols, it is not because we are consciously derived from them but rather because we are concerned with the similar states of consciousness and relationship to the world. With such an objectivity we must have inevitably hit upon a parallel condition for conceiving and creating our forms.

If previous abstractions paralleled the scientific and objective preoccupations of our times, ours are finding a pictorial equivalent for man's new knowledge and consciousness of his more complex inner self.

Mark Rothko

New York Times, July 8, 1945. Rothko exhibited with Gorky, Gottlieb, Horrman, and Pollock at the 67 Gallery in New York. The exhibition was titled *A Problem for Critics*. For the event, Edward Alden Jewell published an article in the *Times* ("Towards Abstract or Away," July 1, 1945) on the new "metamorphosis" of American artists, to which Rothko replies here.

Letter to Barnett Newman, July 31, 1945

Dear Barney & Annalee—

Morton called us a few days ago and brought us first hand reports of you and Provincetown. We of course, are still talking about it, it being quite the best vacation in our memory. Your proficiency and charm as hosts and then the native charm of the place itself—combined are unbeatable.

I am sending you the copies of the Times you must have missed. As you will see, the corpse was never much alive and is quite laid out by now. Jewel is gone and [indecipherable name] has gone philosopher. I called on Howard, only to discover that he had had a mild second attack. He seems alright now. This impressed upon me further the importance of our conversations about your possible function in the picture.

I have produce a number of things since I've returned. I have assumed for myself the problem of further concretizing my symbols, which give me many headaches but make work rather exhilarating. Unfortunately we can't think these things out with finality, but must endure a series of stumblings toward a clearer issue.

I hope that you are jealous and will be spurred to greater labors. Remember your promise of two chapters, one of which I expect by mail in a week or two.

Most of all I am interested in Annalee's new haircomb which I hope that Dianne is continuing in spite of her bad back (which I hope is not bad anymore). I want both of us to have the most beautiful wives in captivity, both of us seeming to have an untenable romantic attitude about this shady business.

I shall turn over Mell, who will say whatever she wants.[19]

Meanwhile love to all of you

Mark

Barnett Newman papers, 1943–1971, microfilm reel 3481. Archives of American Art, Smithsonian Institution, Washington, D.C.

19. Mary Alice, Rothko's second wife, also known as Mell.

Introduction to *First Exhibition Paintings: Clyfford Still,* 1946

It is significant that Still, working out West, and alone, has arrived at pictorial conclusions so allied to those of the small band of Myth Makers who have emerged here during the war. The fact that his is a completely new facet of this idea, using unprecedented forms and completely personal methods, attests further to the vitality of this movement.

Bypassing the current preoccupation with genre and the nuance of formal arrangements, Still expresses the tragic-religious drama which is generic to all Myths at all times, no matter where they occur. He is creating new counterparts to replace the old mythological hybrids who have lost their pertinence in the intervening centuries.

For me, Still's pictorial dramas are an extension of the Greek Persephone Myth. As he himself has expressed it, his paintings are "of the Earth, the Damned, and of the Recreated."

Every shape becomes an organic entity, inviting the multiplicity of associations inherent in all living things. To me they form a theogony of the most elementary consciousness, hardly aware of itself beyond the will to live—a profound and moving experience.

Reprinted with permission from exhibition catalogue (New York: Art of This Century Gallery, 1946), n.p. Rothko introduced the noted abstract expressionist Clyfford Still (1904–1980) to Peggy Guggenheim. Rothko and Still were good friends until the early 1950s, when Still reproached Rothko for having corrupted his style and his aesthetic ideals.

Letter to Barnett Newman,
June 17, 1946

Louse Point Springs
East Hampton, L.I.

Dear Barney and Annalee,
The place is Heaven. Mell [indecipherable]. So you must come out when you
leave for Provincetown. How about next weekend? I am told that once you leave
the Boulevard, traffic is very light.

It was a very good idea for us to get here by train in the morning. The
stores all close at 6 on Saturday. We got here at 1 o'clock, called Motherwell who
again was extraordinary kind, and within an hour were set up with enough sup-
plies for a week. So both of us, I mean you and us, were spared the anxiety and
tension of the [indecipherable] matters. We are very well set up and can entertain
you as you deserve if you come next week Friday or Saturday.

Do you mind letting us know at once. If you find you can't come, could
you call Aaron for us and asking him if he and Jonesey can come. We know that
both of you will be unavailable after this month, and would be unhappy if either
of you couples escaped for the summer without spending some time with us.

If you can come, it would be wise to bring out a blanket or two. (The
nights, are cold here.) and meat if you can—it is very scarce here.) But there are
plenty of chickens & ducks here—if you can put up with these.

So try, we are looking forward to next weekend with you. I think you will
love it as we do. Let us know at once.

Mark

Barnett Newman Papers, 1943–1971, microfilm reel 3481. Archives of American Art, Smithsonian
Institution, Washington, D.C.

Letter to Barnett Newman, August 1946

Dear Barney & Annalee—

Do you realize the summer is almost over. Where did it go to? I do not know whether I told you that we have delayed our trip West until October, and that we will stay here in the county [East Hampton, New York] until then. Well, we did, and this may make it possible for you to visit us out here after you have returned from Provincetown.

Sorry to hear your back etc., I guess it is that which has shot our correspondence for the summer. I hope you have seen my missiles to Adolph[20] in which I have described the local scene. If you recall that we chose our present location to avoid the intrigues of the winter, rest assured that there is plenty here too! I guess our clamor is no longer escapable.

All in all, I find Bob[21] a gracious and interesting guy and Baziotes [22] a swell and vivid person. Pollock is a self contained & sustained advertizing concern and Harold Rosenberg[23] has one of the best brains that you are likely to encounter, full of wit, humaneness and a genius for getting things impeccably expressed. But I doubt that he will be of much use to us. Paalen[24] had been around here, too, also Strop, etc, pale stuff, both! Such is the panorama.

As to work, I am at it and stuff is accumulating, so it seems at least when

Barnett Newman Papers, 1943–1971, microfilm reel 3481. Archives of American Art, Smithsonian Institution, Washington, D.C.

20. Adolph Gottlieb.
21. Robert Motherwell.
22. William Baziotes (1912–1963), artist and member of the New York School.
23. Harold Rosenberg (1906–1978), famed art critic. With Clement Greenberg, Rosenberg was the principal theoretician of abstract expressionism. He created the term "action painting" to designate work by artists of the New York School.
24. Wolfgang Paalen, born in Vienna, 1905, died in Mexico, 1959, a surrealist who emigrated to North America.

I put it together. The few folks around seem to like it, and before our return the situation may even better itself.

Wrote to Betty[25] and sent her the commission on the Bertha Schaeffer sale, and also reminded her about the San Francisco show which opened on Aug. 13–Sep. 8th.[26]

Your letter indicated that you have an ideal set up for work and play and I hope that you are doing considerable of each. I thirst for gossip. Send it without delay.

(Got a letter from Sweeney, who wants to come to see my recent work. (Vos is dos?[27])

Mell is beautiful and sends her love to you and Annalee.

Mark

P.S. Still is now in San Francisco—he has not heard from Betty, Any news?

25. Betty Parsons, with whom Rothko began to show in 1946, the year she opened her gallery. She became Rothko's first manager and organized five one-man exhibitions for him between 1947 and 1951.
26. Rothko is speaking of his exhibition at the San Francisco Museum of Modern Art, his first one-man show in a museum, not counting the 1933 exhibition at the Portland Museum of Art.
27. Rothko seems to have intended the German *Was ist das?* meaning "What is that?"

Letter to Barnett Newman, July 19, 1947

Dear Barney and Annalee—

Have heard from both Hubert & Betty about your father. Wish we were at hand to make things easier for you, because I was always aware of the attachment which you had for him. Perhaps you will find it possible to go away for awhile now and sort of leave everything behind. At any rate, if you can, write us a note and tell us what you are about.

Life here has been hectic for several weeks, but our guests have left one by one and at last we are about as we were. Aaron is now at Los Angeles and will return here before returning East. Before he left has has [*sic*] arranged a show both at the School and at the Legion of Honor Museum. Cliff's[28] show is on, including a number of new ones, and has taken the town by storm. As for ourselves we have been able to extend our stay and will not return until the end of August.

As to the lectures, the whole matter you wrote about never came up and I have never had to deal with it at all. I have had enough nerve to go into these sessions completely unprepared, and just ramble along and perhaps have conveyed many of our mutual ideas with a vividness which would not have been equalled had I tried to organize the material into some sort of system. Our discussions, that is between you and me were strictly a personal matter, and since our terminology differs, our conflicts were never duplicated here.

So all in all, this is a tiring but vivid experience out here. Still I look forward to returning to peace, home and to myself, and think very warmly of seeing you both in the very near future. These weeks fly by quickly.

I send you both Mell's and Barb's warmest love.

Mark

Barnett Newman Papers, 1943–1971, microfilm reel 3481. Archives of American Art, Smithsonian Institution, Washington, D.C. In the summers of 1947 and 1949, Rothko was a visiting professor at the California School of Fine Arts.

28. Clyfford Still.

Letter to Herbert Ferber, ca. fall 1947

2500 Leavenworth
Sunday

Dear Herbert & Ilse,

The city is *unspeakably* beautiful & the weather perfect. We have just returned from a sight seeing cruise around the bay, and already anticipate sadly that the days are going so quickly and that we will leave so soon. The weather is now (and I am told always) benignly autumnal, combining a slight briskness with melancholy —nourishing my Slavic predilections. (We live, in fact, on Russian Hill).

There is no doubt that by its visual attributes alone this city has earned the right to be the art center of the world, and that we must do something to bring this about. I suggest that we defame European art and expose Oriental art —thereby causing the commercial & ideological lanes to shift automatically to the Pacific.

The teaching is painless enough, and by stuttering and stammering my way thru my first lecture I had hoped that it would be my last. But alas, this country, by its climate and disposition loves strange sounds in the night. So it has been decided that this inarticulateness is oracular, and that I must continue. But it at least spares me the anxiety about preparing or making sense.

Our social life has so far revolved about the school—Still, the MacAgys[29] and several teachers which has been exceedingly pleasant. Today however we will undoubtedly enlarge our sphere at a cocktail party which I believe was designed for that very purpose. Then we shall have tons of intrigue, and I assure you there

Archives of American Art, Smithsonian Institution. Rothko wrote this letter during his stay as guest instructor at the California School of Fine Arts, San Francisco. The letter is undated, but in the following letter to Clay Spohn, Rothko refers to Leavenworth Street, where he spent that summer in San Francisco.

29. Douglas MacAgy, director of the California School of Fine Arts.

are tons of it, with which to regale you in front of the fire at your house.

My canvas is dry and my paper stretched. Now if only an idea made its way into my head. No word by the way as yet from S.L. I shall write them in a day or two.

And recalling that lovely farewell party at your house, I send you Mell's warmest love and my own, and remind you that a letter by return mail would be welcome.

Mark

Letter to Clay Spohn, September 24, 1947

1288-6th Ave.
N.Y.

Dear Clay—

This is just a note to let you know that we think of you, and its brevity is a sign that all is still turmoil, transition on the way to an orderly life—which I don't suppose we have ever had, or ever will. Doug & Jerry are here, and when we saw them last week it was just a continuation of Leavenworth Street and all its inmates—as if we had never gone. San Francisco was dimmest the first few days after we left, but its [*sic*] gets clearer and its memory more enticing as more time goes by.

Jerry has been busy gathering millions of pictures for the annual and Doug must have just returned from his paper reading in Baltimore. We like them still and again.

I have already received and stretched the canvases I did in San Francisco. Having been unable to judge them there, I have decided that in that respect all was not lost. Elements occurred there, which I shall develope, and which are new in my work, and that at least for the moment stimulate me—which gives me the illusion—at least—of not spending the coming year regurgitating last year's feelings.[30] The picture I own of Cliff's also arrived and it looks even better than I remembered.

Clay Spohn Papers, 1862–1985: 2, part 2.2: Correspondence, 1925–1981, box 1, microfilm reel 5461. Archives of American Art, Smithsonian Institution, Washington, D.C. Clay Spohn was a professor at the California School of Fine Arts with whom Rothko developed a deep friendship.

30. An important statement. Everything indicates that Rothko is referring in this paragraph to his first "multiform" canvases, the term used to designate his paintings of 1947–1949, which precede the classic format that he would later adopt. Rothko states that certain elements appeared to him during his visit to California, elements that he hopes to develop when he returns to New York.

I think I am beginning to think of Frisco as the classical golden age with the beautiful court and patio and the clear crisp afternoons and our conversations there. I think that you must be quite happy there, now, with your teaching again and working. I hope so.

For the moment give our warmest greetings to Cliff, Hassel & Elmer [31] & all the rest, and that I will write to them soon, and precisely the same for Mell.

Mark

Would welcome a letter very very soon.

31. Hassel Smith and Elmer Bischof, professors at the California School of Fine Arts. Smith's Marxist concept of art often conflicted with those of Rothko and Still.

"The Ides of Art: The Attitudes of Ten Artists on Their Art and Contemporaneousness," 1947

A picture lives by companionship, expanding and quickening in the eyes of the sensitive observer. It dies by the same token. It is therefore a risky and unfeeling act to send it out into the world. How often it must be permanently impaired by the eyes of the vulgar and the cruelty of the impotent who would extend their affliction universally!

The Tiger's Eye no. 2 (December 1947): 44. *The Tiger's Eye*, a cultural journal edited by Ruth Stephan, was published from October 1947 to 1949.

"The romantics were prompted," 1947

The romantics were prompted to seek exotic subjects and to travel to far off places. They failed to realize that, though the transcendental must involve the strange and unfamiliar, not everything strange and unfamiliar is transcendental.

The unfriendliness of society to his activity is difficult for the artist to accept. Yet this very hostility can act as a lever for the true liberation. Freed from a false sense of security and community, the artist can abandon his plastic bankbook, just as he has abandoned other forms of security. Both the sense of community and of security depend on the familiar. Free of them, transcendental experiences become possible.

I think of my pictures as dramas;[32] the shapes in the pictures are the performers. They have been created from the need for a group of actors who are able to move dramatically without embarrassment and execute gestures without shame.

Neither the action nor the actors can be anticipated, or described in advance. They begin as an unknown adventure in an unknown space. It is at the moment of completion that in a flash of recognition, they are seen to have the quantity and function which was intended. Ideas and plans that existed in the mind at the start were simply the doorway through which one left the world in which they occur.

The great cubist pictures thus transcend and belie the implications of the cubist program. The most important tool the artist fashions through constant

Possibilities 1 (1947–1948): 84. *Possibilities* was the first journal conceived exclusively for American art. Only one issue was published, for which Rothko wrote this text. The editors of the journal were Robert Motherwell on art, Harold Rosenberg on literature, Pierre Chareau on architecture, and John Cage on music.

32. Rothko compares his paintings to dramas several times. His ties to the theater were of major importance. His first artistic interests were directed toward the world of theater. In 1924, he took drama classes in Portland, taught by Josephine Dillon. Returning to New York in 1925, he applied, without success, for a scholarship to the American Laboratory Theater.

practice is faith in his ability to produce miracles when they are needed. Pictures must be miraculous: the instant one is completed, the intimacy between the creation and the creator is ended. He is an outsider. The picture must be for him, as for anyone experiencing it later, a revelation, an unexpected and unprecedented resolution of an eternally familiar need.

On shapes:

They are unique elements in a unique situation.

They are organisms with volition and a passion for self-assertion.

They move with internal freedom, and without need to conform with or to violate what is probable in the familiar world.

They have no direct association with any particular visible experience, but in them one recognizes the principle and passion of organisms.

The presentation of this drama in the familiar world was never possible, unless everyday acts belonged to a ritual accepted as referring to a transcendent realm.

Even the archaic artist, who had an uncanny virtuosity found it necessary to create a group of intermediaries, monsters, hybrids, gods and demi-gods. The difference is that, since the archaic artist was living in a more practical society than ours, the urgency for transcendent experience was understood, and given official status. As a consequence, the human figure and other elements from the familiar world could be combined with, or participate as a whole in the enactment of the excess which characterize this improbable hierarchy. With us the disguise must be complete. The familiar identity of things has to be pulverized in order to destroy the finite associations with which our society increasingly enshrouds every aspect of our environment.

Without monsters and gods, art cannot enact our drama: art's most profound moments express this frustration. When they were abandoned as untenable superstitions, art sank into melancholy. For me the great achievements of the centuries in which the artist accepted the probable and familiar as his subjects were the pictures of the single human figure—alone in a moment of utter mobility.

But the solitary figure could not raise its limbs in a single gesture that might indicate its concern with the fact of mortality and an insatiable appetite for ubiquitous experience in face of this fact. Nor could the solitude be overcome. It could gather on beaches and streets and in parks only through coincidence, and, with its companions, form a tableau vivant of human incommunicability.

I do not believe that there was ever a question of being abstract or representational. It is really a matter of ending this silence and solitude, of breaching and stretching one's arms again.

Letter to Clay Spohn, February 2, 1948

Dear Clay—

I want to thank you belatedly for your book, and also your very vivid and chatty letter. We do enjoy your book which one does not read consecutively, but opens it and points at a line, and you are sure to find some part which does the trick— for men like us who seem to fester with indignation.

Your letter has set up again a nostalgia for the last summer which pops up over and over again at any provocation. What was there about last summer which seems now to have been so magical? As I remember there were a lot of pulls and twists which made me at that time wish it were over. Yet you, Clyff, Doug, etc. set up tensions which made us exist, I believe, on a very desirable plane, and I miss it. It seems that it [is] a good condition to live in. The best that can be said about being here, is that one lives nowhere at all—which, too, I wish were over.

Fifty seventh street is a stinking mess. There has been what is apparently an organized attack on "unintelligible" art simultaneously in the N.Y. Times, Telegram, Art News, etc., the firing gun having been opened by Robinson Jeffer's [sic] article in the N.Y. Times magazine section. That in itself does not trouble me. What is amusing is the artists, who being attacked and planning reprisals, are as fearful of their vested interests, and of offending somebody or other, as if they were merchants or peddlars. (The height of these vested interests is Kootz's $50 a week, by the way.)[33] Personally I think that the attack is the greatest signal honor which we have received here in 10 years. To be intelligible to them is dishonorable and suspect.

Clay Spohn Papers, 1862–1985: 2, part 2.2, Correspondence, 1925–1981, box 1, microfilm reel 5461. Archives of American Art, Smithsonian Institution, Washington, D.C.

33. Rothko refers to the business practice of the Sam Kootz gallery, founded in 1945. Kootz used a system whereby, instead of taking a commission on works that had sold, he paid his artists (Motherwell and Baziotes, among others) a weekly salary of fifty dollars in exchange for a guarantee of seventy-five works a year. Kootz later became the agent for Picasso in the United States, thereby acquiring an eminent position in the art world. Cf. Breslin, *Mark Rothko*, p. 253.

So you see there is peace in the very fact of being away from here. Or is there any of it anywhere. The point is that we all ought to be together. How about a mass migration. Please write again. Both Mell and I think and speak of you often.

Mark

P.S. Do not fret about Kitty. Lots more of them. As to Ford,[34] I have never met him. I do know a pal of his, Paalen, who seems to have joined him in excavating, shoveling, back to the land movement, back to everything including nature. Sum total: Rot. They have done it together in Mexico.

34. He is probably referring to Gordon Onslow Ford, an artist and friend of Paalen (on whom, see n. 24, p. 50). Paalen and Ford were cofounders of the artistic group Dynaton.

Letter to Clay Spohn, May 11, 1948

WRITINGS ON ART 1948

Dear Clay—

Just heard from Clyff about your illness—happily in the past, or mostly in the past as I understand—and both Mell and I hasten to wish you well, and tell you that we think of you, talk about you and the summer very often.

Perhaps we did not even answer that long letter you sent us during the winter, but if I could convey a sense of myself as you do you [*sic*] in your letters, I would write with more pleasure and oftener. As it is, I must almost wrench a page of writing out of myself.

I am beginning to hate the life of a painter. One begins by sparring with his insides with one leg still in the normal world. Then you are caught up in a frenzy that brings you to the edge of madness, as far as you can go without ever coming back. The return is a series of dazed weeks during which you are only half alive. That is a history of my year since I've seen you. I am beginning to feel that one must break this Cycle somewhere. For the rest you spend your strength resisting the suction of the shop-keeping mentalities for whom, ostensibly, one goes thru this hell.

I wish we could relive, in a new day, our last summer, for as often as I think of it, I recall it as a momentous time. Perhaps you can plan to visit N.Y. in the near future. Please write to us again. And give our love to Doug, Jerry and all our friends of last summer.

Mark

Clay Spohn Papers, 1862–1985: 2, part 2.2: Correspondence, 1925–1981, box 1, microfilm reel 5461. Archives of American Art, Smithsonian Institution, Washington, D.C.

Letter to Barnett Newman, July 27, 1949

Dear Barney & Annalee—

Excuse our delay. But we have been thinking of you.

First the photographs have arrived and will use them tomorrow.

2nd We hope everything is on the up and up with Annalee's tests.

3rd There is no rest from intrigues anywhere on Earth.

4th Managing a fairly good time.

5th The thing is almost over and are making reservations for New Mexico.

6th Back in N.Y. in the 21st. Hope will find you there.

7th Bringing back some new stills.

8th Weather here not too benign.

9th MaCagys [*sic*] and Still send regards. So do me to you, Bob, Bradley Ferbers & other derelicts.

10 Same from Mell

And we will see you before you know it.

Mark

Leaving here Aug. 11

Barnett Newman Papers, 1943–1971, microfilm reel 3481. Archives of American Art, Smithsonian Institution, Washington, D.C.

Letter to Clay Spohn, October 5, 1949

Dear Clay—

Your letter via La Fonda Santa Fé just reached us a few days ago. It served to recall quite a wonderful few days in New Mexico, which by this time we have almost forgotten, as well as San Francisco. By this time it all seems so long ago.

The reason your letter never reached us is because there was no room at the La Fonda—we had arrived at just the pre-siesta [*sic*] season and the place was swamped. We were lucky to find a tourist camp. Actually we hardly got to stay even there, because we were whisked away by a friend to Ranchos de Taos, where we spent a couple of days. I would say that we spent our entire stay in cars riding about, so that while we met no artists we saw much of this varied and beautiful country. We found the whole experience exotic because we were completely unacquainted with anything in this country like it. We had never been south. Saw just one Indian dance at [indecipherable]. Found that fairly monotonous, but the village in its setting was imposing.

I suppose that school is in full swing by now and life there much as I know it. I hope that by this time you have been able to arrange some of the personal elements in your life so that you are more content, and are able to get ahead also with some of these stray things around your studio, which looked very good to me.

I met, by chance, by the way the English poet when we took over the coals at that last party at your house. He seems to think of it all kindly.

All gossip and news would of course be very welcome. So pass it on to us. Regards from Mell and myself to all our friends and to Marian.

Mark

Clay Spohn Papers, 1862–1985: 2, part 2.2: Correspondence, 1925–1981, box 1, microfilm reel 5461. Archives of American Art, Smithsonian Institution, Washington, D.C.

"Statement on His Attitude in Painting," 1949

The progression of a painter's work, as it travels in time from point to point, will be toward clarity: toward the elimination of all obstacles between the painter and the idea, and between the idea and the observer. As examples of such obstacles, I give (among others) memory, history or geometry, which are swamps of generalization from [which] one might pull out parodies of ideas (which are ghosts) but never an idea in itself. To achieve this clarity is, inevitably, to be understood.

The Tiger's Eye no. 9 (October 1949): 114.

Letter to Barnett Newman, April 6, 1950

Sunday—Paris

Dear Barney—

I realize this must be the day that you are working on Clyff's canvases.[35] And so I send my many thanks and my hopes that Clyff will get something he wants out of the show, or at least not be bruised to deeply.

Unfortunately we have developed bad colds which we got visiting cathedrals which are terribly damp & cold—and the Parisian weather at this time is also abominable. Nevertheless we have carried on until this morning when Mell developed a slight temperature. So I called the American Hospital and they are sending a doctor. But it's slight and all will be well.

I did just want to tell you that from my slight impressions, not all the differences that we had postulated between our own state of minds and that of Paris ever approached even a fraction of the actuality. Never did I ever conceive that the civilization here would seem as alien and as unapproachable as the actuality as it appears to me. Therefore, for Betty's information at least, our reluctance to send pictures over here seems to me to have been correct.

The city is extremely engaging to the eye in 2 respects because of the grandeur, largeness and abundance of monuments which are the more impressive because of their ugliness—and then the many streets and alleys in which crumbling plaster and dangling window shutters form a continuos pastiche of textures.

Barnett Newman Papers, 1943–1971, microfilm reel 3481. Archives of American Art, Smithsonian Institution, Washington, D.C. Rothko and his wife, Mell, traveled in Europe for five months. They left New York on March 29 and visited France, Italy, and England. Rothko wrote several letters to Barnett Newman during this trip.

35. In the mid-1940s, Barnett Newman organized exhibitions for the Betty Parsons Gallery. It seems he was especially helpful in organizing Still's exhibition, which opened the day after Rothko wrote this letter.

A street of buildings in good repair is unendurable. But morally one abominates a devotion to such decay and to the monuments which commemorate nearly everything which I, and France, too must abhor. We visited Chartres whose outside is truly wild—really like N.Y. where the impulse to pile on more stones is never resisted. Nevertheless Paris seems to me no less medieval than Chartres.

These are a lot of ideas to chew in a short space, but I throw them at you for all they are worth. Evenings at Cafés are much like the Waldorf. But the experience by day is quite wonderful, one can continually walk and look.

By the way I sleep fine. I hope you do by this time, too.

I suggest if you write us you address it Amer. Exp., Nice for where we should start in a week. Love to Annalee, and all our friends. We miss you

Mark & Mell

Letter to Barnett Newman, June 30, 1950

June 30, American Express Rome

Dear Barney & Annalee,—

Day after day I have gone to the Express office certain that there would be a letter from Newmans. Ah perfidious ones! So I beg that without delay you send us some news of what has *really* been going in both of you, about Clyff's show, Bradley's, the irascibles and above all the inner and outer state of both of you. I beg you.

You may heard [*sic*] of our good fortune from Herbert that Mell is pregnant—the child having begun his fourth mensis of wombal life. We are happy about it, so happy, that we are leaving the practical considerations until we reach home.

Also there has been very bad fortune. I had one of my recurring foot infections, for which I was given penicillin to which I was allergic. This developed into a nasty two weeks. All in all this has occupied our last month, and I have just begun moving about again. The Luggan's and Gendel's both of whom have cars have been very nice to us in relieving our confinement.

The next week should decide whether we will return home earlier within a month to take better care of Mell's condition and mine or to linger longer. We vacillate.

Since we wrote to you we have done Venice thoroughly and seen some of Rome, but I am hardly in the mood to speak about all these things. This is clearly a beggar's note, that we may hear from you at home.

Our deepest love

Mell & Mark

This must be your anniversary. Our love & congratulations.
What about Tony and where is Jane?

Barnett Newman Papers, 1943–1971, microfilm reel 3481. Archives of American Art, Smithsonian Institution, Washington, D.C.

Letter to Barnett Newman, July 26, 1950

Dear Barney & Analee—

This is from Paris which is now beautiful & cool and are enjoying it very much. At this time this is actually is [*sic*] a stop on the way home. We leave for London in a week and leave Southampton on the 11th of August arriving in N.Y. on the 18th. Our money is getting low, and I want to look for a job.

The three of us are looking forward to seeing you soon. And although the Ben Yochid has missed your written blessings, we are sure that he has them and that makes us feel very good.

Received a very wonderful letter from Tomlin yesterday, also a long delayed one from Rhinehart which was written early in June with all the clippings, etc. It was a delightful letter and I have a deep affection for him.

We would like to go to the country for about three weeks after our arrival. We are writing to both Herbert and Tomlin to look out for something for us in their neighborhood. What are your plans.

Take pen in hand and write us Amer Exp. London.

We are feeling fine and our love to both of you

Mark

Barnett Newman Papers, 1943–1971, microfilm reel 3481. Archives of American Art, Smithsonian Institution, Washington, D.C.

Letter to Barnett Newman, August 7, 1950

London Aug. 7

Dear Barney & Annalee—

Your first letter reached us the last day we were in Paris and your second awaited in London, and we're awfully sorry to hear of your illness and distress. But now with your studio and the calm of summer we expect to find you in good shape. Also please forgive my badgering, but we did miss the absence of word from you worst of all.

We sail on the Mauretania Aug. 11th and are due in N.Y. on Aug. 17th. We are most happy that you will still be around and that we might see your faces at the pier.

Obviously, now that we are coming home and that we have read your report of the end of the season, we must find a way of living and working without the involvements that seem to have been destroying us one after another. I doubt whether any of us can hear much more of that kind of strain. I think that this must be a problem of our delayed maturity that we must solve immediately without fail. Perhaps my ranting against the "club" was no more than a cry of despairing self protection against this very danger.

As to the details of some of the things you wrote about, I did receive an invitation from Kootz for a counter Metropolitan show in the fall. I did not answer the letter because I realized that there was some intrigue [indecipherable] of which [indecipherable] I was going to say "yes" subject to Betty's approval. Then I decided that it may be bad to directly involve her so I did not reply at all.

As to Jane, when we were about to leave Rome, someone told us that she had gone to Milan to study, and so on our return to Paris, since we knew no one

Barnett Newman Papers, 1943–1971, microfilm reel 3481. Archives of American Art, Smithsonian Institution, Washington, D.C.

who seemed to know her we assumed she was at Milan. I am very sorry to have missed her, because we spent nearly two weeks in Paris now.

But we will talk about everything. We are really glad to return, particularly Mell who I think should not strand [*sic*] the strain of this kind of life any longer. So we will see you in a few days. And our best love

Mark

Letter to Barnett Newman, August 1950

1950

Dear Barney—

I hope that things are getting settled for you. We, I think I already wrote you, will not see you as early as we had expected. We will return to N.Y. on Aug. 31st. I am glad you are seeing the Ferbers. They are lovable and please convey them our best as soon as you see them.

As to the Tiger's eyes—I have written them two long letters explaining them just why I do not wish to write anything now, and if they fail to get the point and insist it is a slight of either themselves or their magazine—I simply do not know what to do next.

The first and the *least* important reason is that I think that it would be unfair to Bob even to ask him for his approval of such an idea since the two are being published almost simultaneously.

The second and the second *least* important reason is that on that basis I would have to write still another statement for the Magazine of Art, which at this time I intend to refuse to do. I simply cannot see myself proclaiming a series of nonsensical statements, making each vary from the other and which ultimately have no meaning whatsoever.

The real reason is that at least at this time I have nothing to say in words which I would stand for. I am heartily ashamed of the things I have written in the past. This self-statement business has become a fad this season, and I cannot see myself just spreading myself with a bunch of statements, everywhere, I do not wish to make. I am all the more convinced of that after this marathon of nonsense extending over six weeks.

Barnett Newman Papers, 1943–1971, microfilm reel 3481. Archives of American Art, Smithsonian Institution, Washington, D.C.

You can, if you feel like it, assure the Stephans that it is not a reluctance to write for them. My error in the case of Bob is a thing of the past, but at least I must learn not to repeat it except by desire and conviction. Should I feel differently about it, I shall submit something to them voluntarily at the first urge.

I think you can see the ridiculousness of a succession of 3 statements in a season when I did not even have enough to say for one. Excuse this short letter but will write more personally very soon. Aaron comes back tonight from L.A. and will leave for the East tomorrow. Love to Annalee from Mell and me

Mark

"How to Combine Architecture, Painting, and Sculpture," 1951

I would like to say something about large pictures, and perhaps touch on some of the points made by the people who are looking for a spiritual basis for communion.

I paint very large pictures, I realize that historically the function of painting large pictures is something very grandiose and pompous. The reason I paint them however—I think it applies to other painters I know—is precisely because I want to be intimate and human. To paint a small picture is to place yourself outside your experience, to look upon an experience as a stereopticon view or with a reducing glass. However you paint the larger picture, you are in it. It isn't something you command.

Transcript from symposium at the Museum of Modern Art, New York, published in *Interiors*, May 1951, 10, 104.

Notes from an interview by William Seitz, January 22, 1952

Rothko interview: Jan. 22, 1952

Insists that I write this down as a direct quote:

"One does not paint for design students or historians but for human beings, and the reaction in human terms is the only thing that is really satisfactory to the artist."

remar[36]

art is not a fabrication; a rejection of emphasis on craftsmanship.

Objects to the bauhaus idea, both because it imposes a false unity on the artists . . .

All things done with straight lines are not dead . . .

Unity . . . remarks against unity were made after lunch with gideons [?] who suggested that divergent tendencies of modern department would come to a common meeting. Rothko's reaction "I do not want unity"

"My own work has a unity like nothing" [I do not mind saying even if I appear immodest] . . . [the world has ever seen]

William Chapin Seitz Papers, 1934–1974. Archives of American Art, Smithsonian Institution, Washington, D.C. William C. Seitz (1914–1974) was a professor of the history of modern art at Princeton University and a curator at MoMA in New York from 1960 to 1970. Seitz is the author of the first thesis on American abstract expressionism, begun in 1955 and published in 1983 (*Abstract Expressionist Painting in America*, published for the National Gallery of Art, Washington, D.C., by Harvard University Press). He studied various members of the New York School, Rothko among them. The two met three times between 1952 and 1953. Seitz took notes during these conversations, a copy of which can be found in the Archives of American Art. Even if Rothko was in touch with other art historians, the text of these conversations constitutes a unique document. Moreover, they took place at a crucial moment in Rothko's career, the point when he was consolidating his abstract-classic style. Seitz's notes from the interview are elliptical, and quotation marks are used sparingly. All brackets in the document, including the "[*sic*]," are Seitz's own. Obvious typos of rapid typewritten transcription have been corrected, but the idiosyncratic capitalization and punctuation of the original is retained.

36. Presumably meaning "remarks."

historians unity is a unity of death. What we want is a live unity.

Asked of his statement concerning the fact that an artist works toward clarity: clarity does not have to be dead, *clarity* is a clear presentation of what your meaning is. I: then you could be clear about presenting the exact character of your confusion? yes.

A ruler is clear, in one way. I: do you mean a ruler is dead? No it can be alive.

[One can be a seventh day Adventist, etc. [i. e. separate self from world] Not true of me I live on sixth avenue, paint on sixty third street, am affected by the television, etc. etc. [i. e. diverse particularity of life] My paintings are part of that life.

Objected to my requesting "evolutionary" photos from him, because said he had had several interviews like this. People were always trying to show relationships, evolution, comparison,[37]

The kind of writing we need today is for people to write their responses to painting. To rake in themselves to be able to verbalize what meaning, as humans, the paintings really mean to them.

My conversation tended to be an arguement for historicity as a contributory value to the richer understanding of the artist, while his was an attack at its value, at my position in a tradition which he regarded as a dead hand and a straitjacket. Which killed things by formulation.

"The past is simple; the present is complex; the future is even simpler."

I remarked that his statement was a historical statement. He said, yes it is philosophical [*sic*] in a way . . .

I: Can you have the moment without history?

Answer contained the idea that as soon as you write it down, as soon as you formulate it it is dead.

"We must end this eternal falsification . . . [of history, museums, formulation, comparisons] [i. e. to relate the immediate, untemporalized communication of the painting to the human being who responds to it]

"The problem of living in this world is to keep from being smothered"

37. Seitz defends an evolutionist reading of Rothko's work, founded on the belief that his career can be interpreted as a quest for the essence of painting. Seitz proposes two types of "tests" to support his theory: he identifies a process of elimination of elements like the figure, and an ever-increasing progression toward abstraction, in which Rothko nonetheless kept one important element, which acquired the status of essence in Seitz's interpretation: the background. Rothko refused this type of evolutionary and eliminatory analysis, which he considered idiotic. Rather, he defends a broader approach to his work: the substitution of symbols, which continue to be things, and more precisely, in Rothko's words, "figures."

I: Cannot history—the right type of history—be freeing instead of being smothering? No, because it is institutionalized.

"Today things are institutionalized before they are dry".

I remarked that is a characteristic of the age. This is the period we live in . . .

"So artists resentment is at it highest point!"

Asked do I like paintings I said yes

"I do not like paintings"

I never was interested in cubism. I painted in New York many years while the abs[38] artist [i. e. society] were working. Abstract art never interested me; I always painted realistically. My present paintings are realistic. When I thought symbols were [the best means of conveying meaning] I used them. When I felt figures were, I used them.

I am not a formalist.

I asked about the superficial similarity between his works and Mondrian. Had not consciousness, he said of it. Simply that they both used rectangles?

"I have never had an interest in Mondrian." Later told how, for a joke, he had lectured that PM was obscene painter. I calvinist who spend life caressing canvas.

Trying to bring him out of the development of his work, I remarked that the thing that tied his early figure things, his symbolic things, and his late things together was the backgrounds. That it was as if he had removed the figures for swirling calligraphy, symbol, etc. and simplified the three toned backgrounds.

He said this was silly. Showed the error in an evolutionary approach. It was not, he said, that the figure had been *removed*, not that the figures had been swept away, but that the symbols for the figures, and in turn the shapes in the later canvases were new *substitutes* for the figures.

For transition to later, see four canvases in the Tiger's Eye.

My new areas have nothing whatever to do with the three tier bgs[39] in the symbolic style. There are not [cf. discussion where he says I am different than Mondrian because he *divides* a canvas] My new areas of color are things. I put them on the surface. They do not run to the edge, they stop before the edge.

Notes how false to see connections between early work on basis of evolution.

Connections should be seen when they exist, I said, not when they dont. He agreed.

38. "Abstract."
39. "Backgrounds."

These new shapes say, he said what the symbols said.

Areas are things.

"Not a removal but a substitution of symbols."

He asked me how I reacted to his paintings. I told him I reacted in terms of space, etc. "But what do they *mean* to you. Just because an area like undulating silk is this important? Lots of people can make like silk. Writing should look into the writer and find what the painting really means.

Why have you selected these men, he asked. I did not give a satisfactory answer on account of the context. If you could tell why, he said you felt that these men were on a higher level, why more important . . . they are more important because they are generic, organic [i. e. the originators not painter in the manner of]

When I said I reacted to his paintings in terms of space, etc. "My paintings do not deal in space"

"Mondrian divides a canvas; I put things on it."

I use soft edges. I said they are atmospheric, hence excite an atmospheric response.

"This is an experience" an Experience of depth.

Objection to Bauhaus: I do not live here the same as I do at home. I do not want to admire a chair as art when I sit on it. this is a question of meaning vs. craft.

It is important when meaning can percolate to me.

Why do you oppose intuition? Intuition is the height of rationality. Not opposed. Intuition is the opposite of formulation. Of dead knowledge.

———— memory

Objects to study. Feels his very important work is a great thing is a very special object in the world

Letter to New York Times only a general point of view. Letter statement of a general situation. Would not back it up as a personal point of view.

"We are here drinking wine . . write it down and it is gone." [i. e. quality of experience.]

Objects to painting simply as internal relationships.

I do not like to talk to painters. They go to an exhibition, and remark on design, color, etc. Not pure human reactions. I want pure response in terms of human need. Does the painting satisfy some human need?

Objects to museum which request paintings for an Advance guard exhibition with out knowing why. If they one director was mad, say for Pollock, and had an exhibition of him, this would be good. I refuse to send paintings to such an exhibition, while I would never refuse to send my pictures to an exhibition

based on knowledge. Notes objection to French-American (paired) exhibition planned by Sidney Janis (held 19) where I was to be paired with de Stael. Blobs vs. blocks. they both began with be. Comparisons are false!

Failed to really respond to my remark that the falsely arranged exhibit in Des Moines might create a real picture-observer rapport with someone.

X repros which show up will in b & w. Feels MOMA repros best of late things

On leaving: I did not know you were a painter. Why don't you put first things first. The things students learn in those awful history courses (I have sat trough them) are immediately forgotten. It is only the impact of a personality on them (I am a good teacher—I am passionate) that remains. [Remarked that he teaches senior seminars at Brooklyn College]

Implication: The gesture vs. death. Formalization—death. On the street: I want to keep self out of this. He: "I want to put you back in."

Letter to Herbert Ferber, August 19, 1952

AUGUST 19th, 1952

Dear Herbert & Ilse

Just spoke to your father on the phone. He seems to be O.K. We had hoped to come up there today but the car has carburetor trouble and is in the garage and when it gets out on Wednesday we go to Motherwell's for a few days. When we get back I'll call your father again and see him. I also left our phone number and asked him to call us without fail should he needs company or things.

The time here has been inordinately quiet and we shuffle lazily between park, studio & home. The painting at home & laying of linoleum is completed & a barter under way with Knoll.

The postcard seemed like God's Country & the set up seems just what the doctor ordered. So you should both return well set up. We ourselves are getting little restless and there is a strong impulse to hit the road.

To return to your father, please do not hesitate to call on us for anything whatsoever. We will return by Monday I believe.

Ran up to the Museum show. My room is now inhabited by Marin and O'Keefe [sic]. I must admit that the after-show remaining from my own stuff made those quite invisible for me at least. Leopold's Chapel is the only thing that has remained and I suppose will stay forever. I met and had a long talk with Walkowitz[40] whose glocoma [sic] has made him almost blind. Still he haunts the

Herbert Ferber Papers, 1932–1987, personal correspondence, microfilm reel N69/133. Archives of American Art, Smithsonian Institution, Washington, D.C. Ferber (1906–1991) was an American sculptor. Rothko wrote this letter after the group show *Fifteen Americans* in which he participated at MoMA from April 9 through July 27, 1952. The room where he exhibited contained, at the time, works by Georgia O'Keeffe and John Marin, two eminent modernist American painters.

40. Abraham Walkowitz (1878–1956), a Siberian painter who immigrated to the United States at the end of the nineteenth century, was part of the modernist American movement centered around Alfred Stieglitz.

museum daily. I have always had the highest respect for him. And so it goes. Barney has remained invisible.[41]

Don't let this note make you gloomy. The weather here is heavenly and one walks about in the sun and the breeze really feeling like a million bucks. You up there should feel like two million. Our love

Mark

41. Rothko refers here to Barnett Newman. During these years, their friendship became strained, as did his ties with Still.

Letter to Herbert Ferber, September 2, 1952

SEP. 2nd, 1952

Dear Ilse and Herbert —

Your letter indicated that you are having the best and wisest summer I have ever heard of — doing nothing, which to do with relish is the highest wisdom of all according to Norothustra.[42] Our own trip brought us home thrice exhausted. Kate in contrast insists on doing everything, which produces the opposite of the well being that you are experiencing. I went off with Bob for the weekend, leaving Mell Alas with Kate in the country, to Woodstock, where the perfect weather plus copious drinks and food did much to drown the banal words which were even more copious.

On our return we called your father in the hope of going up there and having him join us. He discouraged us because he waits around for his doctor in the afternoons. He was in excellent spirits, is convinced that he is rapidly improving and spoke of expecting to be able to leave perhaps in a week. From his tone and mood I certainly think that you should stay on as long as you can without anxiety. It may amuse you to know that one of his first remarks was to tip me off about some mural knavery going on at the U.N. which he had read about in the times.

There seems to be no news or gossip important enough to justify the continuance of this wrestling match with the typewriter, so love to you all,

Mark

Herbert Ferber Papers, 1932–1987, personal correspondence, microfilm reel N69 / 133. Archives of American Art, Smithsonian Institution, Washington, D.C.

42. Rothko writes "Norothustra," an unidentifiable name perhaps intended for the ancient religious philosopher Zarathustra.

Letter to Lloyd Goodrich, December 20, 1952

Mark Rothko
1288, 6thAve.
Dec. 20, 1952
Mr. Lloyd Goodrich
Whitney Museum

Dear Mr. Goodrich:

Betty Parsons has informed me that you have asked for two of my pictures to be sent before the holidays to be viewed by your purchasing committee. In view of the fact that I must decline the invitation, I hasten to get these remarks to you due in time.

I am addressing these remarks to you personally because we have already talked about related matters in regard to your present annual; and I feel therefore that there is some basis of understanding. My reluctance to participate, then, was based, on the conviction that the real and specific meaning of the pictures was lost and distorted in these exhibitions. It would be an act of self deception for me to try convince myself that the situation would be sufficiently different, in view of a possible purchase, if these pictures appeared in your permanent collection. Since I have a deep sense of responsibility for the life my pictures will lead out in the world, I will with gratitude accept any form of their exposition in which their life and meaning can be maintained, and avoid all occasions where I think that this cannot be done.

I know the likelihood of this being viewed as arrogance. But I assure you that nothing could be further from my mood which is one of great sadness about

Whitney Museum of American Art Artists' Files and Records, 1914–1966, Artist File on Mark Rothko, microfilm reel N683. Archives of American Art, Smithsonian Institution, Washington, D.C. Rothko wrote this letter to the associate director of the Whitney Museum of American Art. Earlier in 1952 Rothko had refused to participate in the Whitney Annual.

this situation: for, unfortunately there are few existing alternatives for the kind of activity which your museum represents. Nevertheless, in my life at least, there must be some congruity between convictions and actions if I am to continue to function and work. I hope that I have succeeded in explaining my position.

Sincerely,
Mark Rothko

Notes from an interview by William Seitz, March 25, 1953

Rothko Interview, March 25, 1952

"While the Surrealists were interested in Translating the real world to dream, [we] were insisting that symbols were real"

"Pollock made them real."

This means that the artist gave form to the feeling which one would derive from the surrealist dream. Thus it is real experience, [indecipherable] because it is material.

Rothko describes himself as "a materialist." Says his pictures are just made of things.

I am not interested in color. I am interested in the image which is created.

I have created a new kind of unity, a new method of achieving unity.

generally speaking: there is nothing about the 1943 statement which he would repudiate, although says neither he nor Gottlieb wrote it.

None of the Americans artists accepted the symbolism of the surrealists.

Space has nothing to do with my work.

No good painters I know have studied painting.

My experience: I was surrounded by "luxurious sheets". Rothko extend this and suggested write it up just that way.

Agreed influence in one picture by Miró.

Gottlieb was interested in the symbolism of archaic forms where Rothko was interested in the feeling associated with them.

Agreed in representation of ritual objects.

rounded certain corners—did not round others.

When the unity is successful, you can't tell how achieved—because I do not know myself.

William Chapin Seitz Papers, 1934–1974. Archives of American Art, Smithsonian Institution, Washington, D.C. These notes are handwritten.

Notes from an interview by William Seitz, April 1, 1953

Notes from Rothko interview, April 1, 1953

1932–1935
Group of people standing in subway station[43]
Color: all soft greys. Very thin tall figures, like vertical poles. Reminiscent of Giacometti. Ten or more heads tall. Rothko makes point of the difference between his work and the French tradition. Says he understands these canvases now, and insists they are completely his own.

Figure of man second from left holds a newspaper which is reformed into a sort of jugenstill frond—the corners rounded.

Hats, eyes, purses of ladies, etc. mere dots of paint

Figures has a wraithlike, wan, ephemeral existence, each, like those of Giacometti, involved in his own world.

Reveal the outer colorlessness of existence, as if they had been squeezed to elongation by the solidity and pressure of the surrounding atmosphere.

cf. Rothko's quotes on human incommunicability and the solitary figure, etc.

Girl in Subway[44]
All in whitish greys, cool and warm (mainly cool) except dark umber of receding perspective. The perspective focuses so obviously on the girl that it is like strings radiating from her hand. Mannering the perspective, surrounded by rectangulated areas of grey, so that its depth does not read. Opaque areas painted over revealing scratched areas—with knife in a sort of imprimatura.

William Chapin Seitz Papers, 1934–1974. Archives of American Art, Smithsonian Institution, Washington, D.C.

43. Rothko is commenting on the work *Underground Fantasy (Subway)*, ca. 1940, National Gallery of Art, no. 3261.30.
44. *Girl in Subway: Subway*, 1939, Brooklyn Museum of Art.

Boy standing before dresser and window.[45] Through window blue and pink. dresser soft green. Pink wall outside. Boy wears yellow sweater, blue pants. Light comes around sides with shadow in center of figure, shirt, etc.

The Ten were Solman, Lee Gatch, Bolotowsky, etc.

Boy at drawing table with T squares, etc.—geometricity

The figures in these canvases are immobile, inanimate, held by parallel planes of grey—few recessions. When there is life, it is the strokes of paint and the lines which make up the features which have life; the vitality of pure form. Later in the canvases of 1939–1942 a new life begins. It is the inner life. As if each of the uncommunicating figures of the subway lived a rich inner life. Emotionally evocative shapes and colors are sought.

An in 1945–47 the specific symbolic world begins to dissolve into pure painterly means: line, area, and *parallel* planes.

1939–1943–4?

Here, begins of bird symbolism and stronger colors: pinks, blues, Rothko says first use a sacrificial title.

(cf. statement that subject matter must be tragic)[46]

Uses forms which strongly suggests archaic idols, ritual objects, birds, plant forms (cf. vegetable gods, etc.) Emotional involvement with utter things; the universality of myth. Its "ubiquitous" quality.

_____ check times

Period of "White paintings" and calligraphy, 1945–1948

Check big horizontal without name,

soft whitish greys, transparent or scumbled, but always with conscious-ness of picture plane, rectangles, and axes, and about it an aura of ritual importance, feeling.

1948

5 dark splotches of black, edged out to soft browns, light fans, and pink.

"I am not interested in color"

Image ends before edge of canvas (not true of earlier canvases, in which "background" was cut off by frame giving shapes a formal assertion and an independence.

Receding horizons, landscape. Splotches are foreground elements, but can only be read as splotches.

45. *Untitled (Portrait)*, 1938, collection of Christopher Rothko.
46. See the letter to the *New York Times* of 1943 (pp. 35–36, this volume). Rothko and Gottlieb asserted that "the subject is crucial and only that subject matter is valid which is tragic and timeless."

7 1949, vertical

Note that here, as often, begins with a colored priming. Only edge of priming shows, and it forms a background between the colors laid over it.

#No. 17, 1949 (see plate)

Areas are independent and influence each other because they stand in a limited rectangular area. Their edges are softly scrubbed over each other for the "background". They almost become planes (that is, they begin to take tilted positions cf. cold blue-grey at rt.) The "front" edge is held by its proximity to the canvas (parallels it) so that the other is forced to recede—but can be read opposite.

When an area tips into depth it becomes a plane—as it does in parallel when it leaves the actual canvas surface and moves either forward or backward.

Letter to Katharine Kuh, May 1, 1954

Mark Rothko
102 West 54th St.
New York City
May 1, 1954

Dear Miss Kuh:

I am very glad that you were able to arrange the exhibition. And I think that you are inaugurating something very worth while, and the date you have arranged seems very good, too.

I will be in New York on July first and will expect you.

Please excuse the delay in answering, but your letter caught me in the midst of moving.

Sincerely,
Mark Rothko

Katharine Kuh Papers. Institutional Archives, Art Institute of Chicago. Katharine Kuh was art critic and head of exhibitions at the Art Institute of Chicago. In 1954 she proposed giving Rothko a one-man show. This exhibition took place from October 18 through December 31 of that year. In conjunction with the exhibition, she suggested publishing their written interviews, presented in these thirteen letters. Because of Rothko's reticence, these were never published.

Letter to Katharine Kuh, July 14, 1954

102 W. 54th St.

July 14

Dear Katherine Kuh:

Thanks for your letter. It has had the effect of starting me in the attempt to collect my thoughts and setting them down. I hope that soon I will be able to send you something that at least from this side will seem right.

You write that what you would really like to know is what I am after, how I work and why I have chosen the particular form which I use. I hope that some kind of answer to these questions will be implicit in our correspondence before it is completed. May I suggest, however, that at this time we abandon any preconceived notions of what ought to be said and printed. For unless we do, it will bind us to a course which will inevitably lead to the meaningless banality of forewords and interviews. And I doubt the usefulness for us of the question and answer method for uncovering anything of meaning and interest.

Rather than create the pretense of answers to questions which either should not be answered or which are essentially unanswerable, I would like to find a way of indicating the real involvements in my life out of which my pictures flow and into which they must return. If I can do that, the pictures will slip into their rightful place: for I think that I can say with some degree of truth that in the presence of the pictures my preoccupations are primarily moral and that there is nothing in which they seem involved less in than aesthetics, history or technology. To that end nothing would be more stimulating to me than if you could find some way of indicating the real nature of your own involvements in the world of art and ideas, which, if I am at all a good judge, are very intense and human.

Forgive me if I continue with my misgivings, but I feel that it is important

Katharine Kuh Papers. Institutional Archives, Art Institute of Chicago. This letter is an essential document for understanding Rothko's aesthetic positions.

90

to state them. There is the danger that in the course of this correspondence an instrument will be created which will tell the public how the pictures should be looked at and what to look for. While on the surface this may seem an obliging and helpful thing to do, the real result is the paralysis of the mind and the imagination. (and for the artist a premature entombment.) Hence my abhorrence for forewords and explanatory data. And if I must place my trust somewhere, I would invest it in the psyche of sensitive observers who are free of the conventions of understanding. I would have no apprehensions about the use they would make of these pictures for the needs of their own spirits. For if there is both need and spirit there is bound to be a real transaction.

It is precisely because I feel that there has been such a transaction here that I hope we can succeed in this mutual effort. Please write to me soon.

Sincerely,
Mark Rothko

P.S. I want to apologize for not having aknowledged [*sic*] the receipt of the blue print. The room seems very good to me. I expect to find the print in valuable in the final choice of pictures.

Letter to Katharine Kuh, July 28, 1954

102 W 54
July 28

Dear Katherine Kuh

I would like to tell you how things have been going at this end. From the time I received your first letter I have been writing down ideas as they came to me. By now there is considerable material which represents these ideas in the best way that I can now state them. Would it be time enough if I sent you a draft by August 15th? I set that date as a goal for myself in which to make this material coherent and legible.

I would like to suggest that the draft I will send become the heart of what will be printed. I realize that this suggestion disturbs our original hopes about our correspondence; but try as I will, I cannot directly answer the questions posed in your letters without distorting my meaning. At the same time, I feel that the material as it is shaping up, will illumine many of the things which you would like to know in the best possible way known to me.

From the moment that I began to collect my ideas it became clear that here was not a problem of what *ought* to be said, but what it is that I *can* say. The question and answer method at once presented insuperable difficulties: for the question imposes its own rhetoric and syntax upon the answer regardless of whether this rhetoric can serve the truth, whereas I have had to set for myself the problem of finding the most exact rhetoric for these specific pictures.

If, for example, I were to undertake the discussion of "space" I would first have to disabuse the word from its current meanings in books on art, astrology, atomicism and multidimmensionality [*sic*]; and then I would have to redefine and distort it beyond all recognition in order to attain a common meeting ground

Katharine Kuh Papers. Institutional Archives, Art Institute of Chicago.

for discussion. This is a dangerous and futile battle. The strategy may be brilliant but the soldier is dead.

The actual fact is that I do not think in terms of space in painting my pictures, and it is better to let myself find my own words at the right time, and I will come closer to the feelings about my pictures which you have so vividly described, and which I think I understand, and respect.

At the same time your letters are invaluable and I hope that you will send them whenever you can, and suffer my inadequate replies. They help sharpen issues and my ideas about them. And above all, they make of you a concrete audience to whom I am addressing thoughts, whose warmth and understanding make me want to be truthful and clear.

Sincerely,
Mark Rothko

Letter to Katharine Kuh, ca. August 1954

Dear Katherine Kuh—

I wanted to thank you for your sympathy and understanding. At any rate, our telephone conversation gave me a much needed release to the studio, which was requiring my full attention.

I did want to tell you that you did start a process of speculation about ideas and work, in which I have not engaged for some years, and which I find valuable and enlivening, and for this again I want to thank you.

At some time or other, when I can do it without the present strain, I will carry it to some conclusion and then, if I may, I would like to send it to you.

As to the exhibition, it is important for me to know, as soon as you have the information, when the pictures will be called for shipment, and whether the 8' x 10' canvas which will be the largest can be shipped without rolling, and who the agent is here with whom I can discuss shipping methods.

I wish you the happiest vacation both here, and when you go to David Smith's. My best regards there. And I am always very happy to hear from you.

Mark Rothko

Katharine Kuh Papers. Institutional Archives, Art Institute of Chicago.

Letter to Petronel Lukens,
August 18, 1954

102 W. 54th St. N.Y.C.

August 18, 1954

Mr. Petronel Lukens[47]

Chicago Art Institute

Dear Mr. Lukens:

Thank you for your letter and am relieved and pleased that my pictures will not need to be rolled.

What did surprise me was your request that the pictures arrive in Chicago by Labor Day, for I had been told by Mrs. Kuh in a letter to me on June 3rd and which I have before me now, that "the paintings will not have to leave New York before late in Sept."

There are important reasons why the later date is preferable to me, among them: that several people from abroad expect to see some of these pictures in my studio shortly before Sept. 15th, and that it would be beneficial to have a longer time to study the selection which I have made.

Unless this seriously disrupts Mrs. Kuhs plans I should like to send them soon after Sept. 15th. Or if there are other serious problems of which I am not aware, please let me know, and I shall do everything I can to cooperate.

In the meantime I shall get in touch with Budworth,[48] and on the basis of your letter, I hope that I can consult with them on the proper preparation of the pictures for their protection in shipment.

Sincerely,

Mark Rothko

Katharine Kuh Papers. Institutional Archives, Art Institute of Chicago. Lukens was assistant to Katherine Kuh.

47. Rothko seems at first to have mistakenly assumed that Lukens was a man.
48. The name Budworth appears often in the records of Chicago's museum, presumably referring to a business specializing in the packing and shipping of paintings.

Letter to Petronel Lukens, September 12, 1954

Mark Rothko
102 W. 54th St.
New York City
Sept. 12, 1954

Mr. Petronel Lukens
The Art Institute of Chicago
Chicago, Ill.

Dear Mr. Lukens:

Thank you for your good advice. I have consulted with Budworth and have arranged for the paintings to be collected on Sept. 17th. There are nine paintings as requested by Miss Kuh in her letter in June. Budworth has assured me that these should reach you by Oct. 1st.

My pictures are designated by number and year. The following is a list of those to be sent and the corresponding price at which they are to be sold, to the public.

#12	—	1951	$1,000
14	—	1951	1,300
10	—	1952	4,000
7	—	1953	1,800
6	—	1954	2,000
9	—	1954	2,000
11	—	1954	2,250
4	—	1953	1,800
1	—	1954	2,500

Katharine Kuh Papers. Institutional Archives, Art Institute of Chicago.

I hope that this provides for you the necessary details to place your customary insurance protection for the pictures and to inform Budworth. As soon as the pictures have gone I will write in detail about sizes and other pertinent matters to Miss Kuh so that she may have the information before the arrival of the pictures.

Thank you again for your help.

Sincerely,
Mark Rothko

Letter to Katharine Kuh, September 20, 1954

Monday, Sept. 20th.
102 W. 54th

Dear Katherine Kuh:

I would like very much to have the show extended and thank you for making the opportunity. At the moment I cannot see why it should not be possible. Would it be time enough if I took until Friday to check dates and several other kinds of considerations involved, so that you would have definite word by Monday? I believe that the Providence show opens on Jan. 19th. I am not now sure that I will use any or all of the same pictures there. But I would like to make sure that this will be possible if it seems the thing I wish to do at that time.

Now that the work is already at Budworths I wish to tell you that I feel very good about sending it to you and that I am deeply grateful for the consideration with which you have acted toward the work and attitudes. I sent nine pictures, seven of which you chose and two which were painted since your visit here whose inclusion, I felt, significantly added to the scope of the group. I hope that the group seems as right to you as it did to me in the studio.

I am enclosing a photograph which I hope can suit your purposes.

I will write you again this week end about the dates and will add whatever I can think of that may be of use. And now that your wanderings are over I hope that you feel refreshed, invigorated and well

Sincerely,
Mark Rothko
P.S. If it is possible to credit the photograph, I know that the photographer would like it very much.

Katharine Kuh Papers. Institutional Archives, Art Institute of Chicago.

Letter to Katharine Kuh, September 25, 1954

102 W. 54th St. N.Y.C.

Sept. 25, 1954

Dear Katherine Kuh:

Budworths thought that if the pictures could be delivered to the shippers very promptly at the close of the exhibition, they could arrive either Providence or New York by the tenth of January, which would be fine. I am assuming that this can be done, and would therefore be very glad to have the exhibition extended until the end of December.

Although I have studied the blue prints carefully, I realize that it is impossible for me to visualize the real feeling of the room and what the hanging problem will be. I thought that it may be useful to tell you, here, about several general ideas which I have arrived at in the course of my own experience in hanging the pictures. These may be or may not be helpful in the present situation.

Since my pictures are large, colorful and unframed, and since museum walls are usually immense and formidable, there is the danger that the pictures relate themselves as decorative areas to the walls. This would be a distortion of their meaning, since the pictures are intimate and intense, and are the opposite of what is decorative; and have been painted in a scale of normal living rather than an institutional scale. I have on occasion successfully dealt with this problem by tending to crowd the show rather than making it spare. By saturating the room with the feeling of the work, the walls are defeated and the poignancy of each single work had for me become more visible.

I also hang the largest pictures so that they must be first encountered at close quarters, so that the first experience is to be within the picture. This may well give the key to the observer of the ideal relationship between himself and the rest of the pictures. I also hang the pictures low rather than high, and particularly

Katharine Kuh Papers. Institutional Archives, Art Institute of Chicago.

in the case of the largest ones, often as close to the floor as is feasable [*sic*], for that is the way they are painted. And last, it may be worth while trying to hang something beyond the partial wall because some of the pictures do very well in a confined space.

All of these, of course, can be only conjectures at this far distance. I send them in the event that they might be stimulating or helpful.

It would be best if all nine could be hung for I have thought of them as a group. I realize that this may be impossible. Would you send me the numbers if any are omitted. It would help me to visualise the show. I, of course, would like to see it. You mentioned the possibility of my being brought out on the basis of a lecture. I would like to entertain the idea if one can be arranged.

I hope that you feel as warmly about the pictures when they arrive as you seemed in the studio, and that the feeling continues thruout the exhibition.

Very sincerely,
Mark Rothko

Letter to Katharine Kuh,
September 27, 1954

Mark Rothko
102 W. 54th St.
New York City
Sept. 27, 1954

Mrs. Katherine Kuh
The Art Institute of Chicago

Dear Katherine Kuh:

As I had informed you at our last meeting in New York, my relationship with the Betty Parsons Gallery was terminated last spring. In the event that there is any printed matter relating to the exhibition which involves credits, please have the pictures designated as "lent by the artist." Also that all transactions in the case of possible sales, or any other matters, be made directly with me.

 Since you were concerned, I would like to tell you that the commission of ⅓ of the selling price, which I allow on my pictures in the event of sale, is to be divided between the Museum and Betty Parsons. I have informed her that Miss Lukens has written that the Museum charges a 20% commission, and that I will turn over the remainder of the commission to her. Should she write to you and succeed in negotiating any other division of this commission, please let me know.

 Sincerely,
 Mark Rothko

Katharine Kuh Papers. Institutional Archives, Art Institute of Chicago.

Letter to Katharine Kuh, October 20, 1954

October 20th, 1954

Dear Katherine Kuh,

Thank you for the very kind words which you have written about the exhibition. Between the lines of your brief but eloquent letter, I read, that as far as the audience is concerned, it must be rough going for you and the pictures. You must have known in advance that this would be so, and I admire your courage in putting them up.

As to my coming out—even tho' I had myself suggested a lecture, I find that I have not he stomach for the role of apologist for the pictures in such proximity to the exhibition, both as to time and place. Your letter has confirmed my feelings, and perhaps by this time you yourself may agree that I am right. It would be nice if, at some natural pause in the work in my studio I could board a train and come and enjoy myself with you and those who have enjoyed my pictures. But my circumstances will not allow it. Excuse me, therefore, for the unnecessary trouble I have caused you in making the arrangements you did.

I will appreciate any details you can send me about the course of events. It would make the exhibition much more real to me. It is a disturbing thing to have the pictures hung at such a distance. I am very grateful that you are there, and that you are for them.

Sincerely,
Mark Rothko
P.S. Could you please send me the number of the picture which you were not able to hang, and if there is any printed announcement of the exhibition, could you send me a number which I might send to friends who might find their way to Chicago before the show is over.

Katharine Kuh Papers. Institutional Archives, Art Institute of Chicago.

Letter to Katharine Kuh,
October 23, 1954

October 23, 1954

Dear Katherine Kuh,

This afternoon, just by chance, I received the first outside report about the exhibition. I encountered a Mr. & Mrs. Walter Landor of San Francisco who had just flown in from Chicago. They expressed what seemed to be a genuine admiration for the exhibition and the way in which the pictures were presented. They described in particular the way in which the large picture functioned, vividly and enthusiastically.

The encounter helped to make the show more concrete to me and gave me a good deal of pleasure, which I wished to pass on to you without delay, with the thought that it might also please you.

By the way, since you do come to New York frequently do you plan to be here in the near future? It would be good to see you and talk with you.

Sincerely,
Mark Rothko

Katharine Kuh Papers. Institutional Archives, Art Institute of Chicago.

Letter to Katharine Kuh,
November 29, 1954

102 West 54th St.
New York City
Nov. 29th 1954.
Katherine Kuh
Chicago Art Institute

Dear Katherine Kuh,
I would like to write to you at length about many things that we talked about during your visit here. I will have to be brief however as I wish to have this in the mail soon so that you can effect the insurance for the picture in time. The picture will leave my studio this Wednesday morning Dec. first; and I imagine will leave for Chicago by the week end. The figure of $4000 was correct.

Needless to say I was very much pleased by the interest in my big pictures for many reasons which we had discussed, and I by no means underestimate your feelings and your work in their behalf in this turn of events. I enjoyed both Mr. Kaufman and Mr. Rich and their reactions to the work and hope that you find yourself as responsive to the picture as they seem to have been.

I did want to add that I was not disappointed that the lecture had not materialized. While I wanted to see the show, I would have been disturbed by the disruption of the continuity of my present immersion in my work. In this way the temptation has been removed.

I send you again my warmest regards and feelings, and my family adds theirs, and we all hope that you will visit us here soon.

Sincerely,
Mark Rothko

Katharine Kuh Papers. Institutional Archives, Art Institute of Chicago.

Letter to Katharine Kuh, December 11, 1954

Mark Rothko
102 West 54th St.
New York City
Dec. 11, 1954

Dear Katherine Kuh,

Due to Mr. Kaufman's effort and energy, we have obtained a wide cylinder around which the picture will be rolled, and will be picked up by Budworth on Monday morning. I am sorry that I did not know that it was Budworth who made the first arrangements impossible, for all of this delay could have been avoided. May I say that I have been deeply touched by Mr. Kaufman's relentless efforts to get this picture to Chicago as well as your efforts in this matter.

Mr. Kaufman has suggested that it will be a simple matter for your staff to make a stretcher for the picture, (my own being so often patched in repeated usage, that its reassembling would be too difficult.) I would like to send you the following information about the picture and suggestions about the stretcher that may be a help. The painting is about ¾ of an inch shorter in the centers than it is at the ends. Therefore I suggest that the stretcher be built of wood no heavier than one by three inches and that the crossbars be placed towards the sides and not in the center, as I indicate in the drawing.[49] In this way the wood will be able to give enough in the center without putting too much of a strain on the center of the picture.

In a few days I will be able to write about the shipping of the pictures

Katharine Kuh Papers. Institutional Archives, Art Institute of Chicago.

49. After this paragraph, Rothko illustrated his meaning with a rough sketch.

back. Thank you again for everything, and as the exhibition draws to a close I hope that the pictures still wear well with you.

Sincerely, Mark Rothko

The painting is 117 ⅞ x 105 ⅞ at the outer corners. I will send the old stretchers along anyway in case that they are useful.

Letter to Petronel Lukens, December 16, 1954

Mark Rothko
102 W. 54th St.
New York City
Dec. 16, 1954.
Petronel Lukens
Art Institute of Chicago

Dear Miss Lukens:

Please ship all of the paintings to Providence, Rhode Island. If the painting committee decides to retain any of the paintings, please let me know which it is as soon as possible, so that I may be able to substitute one from here in ample time.

The large painting requested by Mr. Rich and Mr. Kaufman was collected by Budworth on Monday the fourteenth. It should reach you very soon. I sent along the four outer stretcher sticks and marked in red letters on both the sticks and the folded over edge of the canvas to indicate their proper positions. As I have indicated to Mrs. Kuh, I do not know whether the stretcher can be used because the slots which fit into each other are all gone.

I would appreciate it very much if I could have copies of the newspaper items and letters about which Mrs. Kuh spoke. If these cannot leave your files, I would be happy to pay of photostats of same.

Cordially,
Mark Rothko

Letter to Katharine Kuh, ca. 1954

Dear Katherine Kuh,

I sent off a letter to you yesterday and remembered that you had asked for the return of yours.

It occurs to me that it would be well for both of us to have copies of the full correspondence. Therefore I have made a copy of yours and have retained one of my own. I think it would be easier if we both retain copies of our own before we mail them. In that we shall both be able to contribute suggestions, at the end, which may prove welcome.

In the agonies of writing, I have failed to wish you a most delightful and restful vacation, and I hope that there will be some way that we can meet before your return to Chicago to discuss both the correspondence and the pictures for the exhibition.

Sincerely,
Mark Rothko

Katharine Kuh Papers. Institutional Archives, Art Institute of Chicago.

"Whenever one begins to speculate," ca. 1954

Whenever one begins to speculate about the nature of art, I have never been able to find more pregnant rhetoric, or symbols than those of the Greek Gods, especially if you have a western mind, and are at best a reluctant traveler on esoteric and rarified planes. For the Greek Gods in their functions were shrewd to codify both the qualities, the possibilities as well as the limitations of human expression. And while language seems to have been designed to obscure thoughts by its proclivity to diversion, such was the nature of the Gods, such was their relations to the Greeks over whom they ruled, that the Greeks could, by that same guile and deceit which they practiced against each other, overcome the intent of the Gods as to how much language might be allowed into the truth before it became dangerous. It seems that the role of the artist is to pry and prod at the risk of the destruction which were the wages that might come of invading forbidden ground. A few escaped destruction & came back to tell the tale.

It was many years ago that I encountered a reflection upon this relationship in the Birth of Tragedy of Nietzsche. It left an indelible impression upon my mind and has forever colored the syntax of my own reflections in the questions of art. And if it be asked why an essay which deals with the Greek tragedy should play such a large part in a painter's life (for the arts I do not believe can imitate each other), I can only say that the basic concerns for life are no different for the artist, for the poet, or the musician. And to be reminded that what can be snatched [indecipherable] from the Gods depends upon ruses, which can neither be taught

Fragment of essay on Nietzsche and Greek gods. Rothko's papers. This text and the two that follow are not dated. In them, Rothko alludes to a questioner to whom he hopes to explain the essence of his art. My theory is as follows: Rothko probably prepared these texts to send to Katharine Kuh (see the letter of July 28, 1954, p. 92, this volume: "I have been writing down ideas as they came to me. By now there is considerable material which represents these ideas in the best way that I can now state them." These texts evoke the relation of Rothko's painting to space and the ties between his current painting and previous works.

nor learned, since you can never trick the Gods in the same way twice, and hope that this explains my rapture.

The question of what can be wrenched, and how it can be brought into use—for like a stolen jewel of great value, it can be exhibited only under certain disguises and conditions . . .[50]

50. Fragment ends here.

"Relation to one's own past," ca. 1954

You ask how I got started in the direction which I am now following. It of course immediately raises the hope of a logical and ordered continuity for your painting life in which one thing is solved and gives rise to the next and then the next with a continuous development. But alas, when one looks at this past how many distractions, how many dark alleys, and how much wandering. I know that in my case there were many such.

Yet when I had the occasion to look recently at a group of my pictures which were painted twenty years ago, it seemed to me that the paintings had greater meaning to me than they possibly could have when they were painted. This was in the light of what happened in my work afterward. For there appeared an aspiration in those old paintings for the present. Unfortunately that understanding can be achieved only backwards, for while at this time they seem so logical as a prelude for the present work, it would have been impossible to imagine then, the present resolution to which the pictures have arrived, just as at this moment, I can have no prescience of the things which yet will come.

Rothko's papers.

"Space in painting," ca. 1954

It occurs to me in our discussion of space that it would be profitable to use synonyms which are more concrete in subjective attributes, as for example depth for the experience of depth is an experience of penetration into layers of things more and more distant. Again, referring to the subjective elements, when we wish to express concretely an image of intensity of feeling, for instance, we say depth of feeling or penetration into knowledge or revelation, which means the removal of veils, which is the coming out of a depth into the frontal understanding, or the unfolding of veils which have obscured what is behind them. I say that all of these are manners of expressing our dependence upon the sensations of things being closer and farther for the purpose of establishing a real relationship. Therefore, in the terms of the desire for the frontal, for the unveiled, for the experienced surface, I would say that my pictures have space. That is in the expression of making clear the obscure or metaphysically of making close the remote in order to bring it into the order of my human & intimate understanding.

What I have always responded to in paintings is the clarity of such handling, no matter what the period or subject. Here, says the painter, is of what my world is composed: a quantity of sky, a quantity of earth, and a quantity of animation. And he lays them out on the table for me to observe at the same distance, to hold in the palm of my understanding without editorship—and these are eyes or a head—that are the desires and fears and aspirations of animated spirit.

Rothko's papers.

Letter to Katharine Kuh, January 11, 1955

Mark Rothko
102 West 54th St.
New York City
Jan. 11, 1955

Dear Katherine Kuh,

The check arrived yesterday, and I want to sincerely thank you, once more, for everything you have done in behalf of my pictures during the past months. It is needless to tell you how greatly this transaction contributes to the peace of mind with which my present work is being done. I am also happy that this specific picture has found a place, for I wonder, often, how my large and important works can physically survive.

I have informed Betty Parsons, who has just returned to New York, about the sale, and she will receive by Friday—when your check will have cleared my bank—the remainder of the ⅓ commission, which amounts to $733.33. This was an arrangement understood by all concerned, and about which I wrote you prior to the opening of the exhibition. I am very glad that this coincides with your own wishes.

Should you have a moment, I would be grateful if you could gather whatever printed matter and letters which occurred in connection with the exhibition and send them on to me. Should you need them for your own files I will return them shortly.

I hope that your affairs will bring you to New York soon and that you will again come to see us. My family joins me in sending you our best wishes and regards,

Sincerely,
Mark

Katharine Kuh Papers. Institutional Archives, Art Institute of Chicago.

Letter to Herbert Ferber, July 7, 1955

July 7 1955

Dear Motherwells and Ferbers

Let us make ourselves at home at once by telling you how Gerry Levine and the Byrnes[51] came to visit us and the manner of our meeting. It is so characteristic.

We purchased a car here from a dealer recommended for having a reliability to be found only West of the middle west. The car was guaranteed to take us enthusiastically to every point of wonder in the vicinity. It was eight miles up Boulder Canyon that our radiator gave out. We were waving our arms frantically for help and who stopped to help us? Gerry Levine, Mr. and Mrs. Byrnes, Inez Johnson, and one dog. It was wonderful to see them, for the smell of their contact with you and of that Paradise, N.Y. still lingered about their clothes.

We spent the July 4th weekend at Colorado Springs. Gerry was there when we arrived but left the same evening, and we have a date with the Levines to do Aspen about the middle of August when the Goldberg music will be there.

The Byrnes were excellent hosts, and let me say that their devotion to you is of an intensity and wholeheartedness that occurs only in the undevout. I would say that for that I forgive the real shoddiness of their enterprise and that of the *world* in which it operates. We also met and talked at length with Grove and Wolfert to whom your presence there last year is acutely memorable.

We spend our time here in search of a human being. In the course of our being entertained here not too infrequently, there was no trace of one. Our desperation forces us to hold on to hope.

Herbert Ferber Papers, 1932–1987, personal correspondence, microfilm reel N69/133. Archives of American Art, Smithsonian Institution, Washington, D.C. Rothko wrote this letter from the University of Colorado at Boulder. He taught a ten-week course there during the summer of 1955.

51. James Byrnes was director of the Colorado Springs Fine Arts Center.

Two things we feel very good about. We live in a faculty development, which is devoted to breeding wholeheartedly and as a result there are many friends for Kate and we have periods of relief from her which we needed so badly.

Secondly, living here, we have a glimpse of the University of today and a mysterious future which it portends which I would never have understood otherwise.

The Geographic situation makes it microscopically vivid. The University itself is on the hill. At its base are the faculty apartments which are shells around appliances facing a court into which the children are emptied. Two hundred yards away is Vetsville, in which the present faculty itself had lived only four or five years ago when they were preparing to be faculty. Vetsville itself is occupied by graduates from army quarters, already married and breeding who will be faculty in faculty quarters three or four years hence. They breed furiously guaranteeing the expansion which will perpetuate the process into the future.

The faculty itself is allowed to stay here only 2 years whereupon they must assume mortgages in similar housing slum developments where thereafter they must repair their own cracks and sprinkle their grass.

One member of our department is fed up, so he is leaving for a job at Union College, Schenectady. He is all set and has been provided quarters at the Faculty apartments there.

Here is a self perpetuating peonage, schooled in mass communal living, which will become a formidable sixth estate within a decade. It will have a cast of features, a shape of head, and a dialect as yet unknown, and will propagate a culture so distorted and removed from its origins, that its image is unpredictable.

Excuse me for this long harangue. But let me tell you one East, West incident which may amuse you. Buying a car found me in a series of transactions in which it was known I was from New York. First the dealer hinted that he couldn't understand how anyone could live in N.Y.; the license plate man said he had been there once, had enjoyed the noise (how can anyone stand it), but once was enough; the clerk who gave me the eye test hinted at the corruption of large centers, etc., etc. Finally we left the station, the dealer renewed the chant. In a moment of folly, I stopped him and passionately described for him the great cities of the world, Paris, Rome, London (and threw in Berlin and Oslo for local ethnic reasons). And, I added, of all these wonders, New York was the greatest wonder of all.

He smiled his slow Rocky Mountain smile. "I wouldn't go to one of them places either," was what he said.

So how can you win. Love to all of you from us and Kate and please write.

Mark

Letter to Herbert Ferber, July 11, 1955

July 11th 1955
1255-19th St.
Boulder, Col.

Dear Ferbers—

We have just mailed a community letter to you and the Motherwells. We mailed it to Robert for it contains much gossip pertinent to his stay in these parts a year ago. But there also are included my meditations on this physical and human desert which I hope will strengthen our raphsodies for that island of Paradise which is N.Y. City, and I am so happy that in buying a farm you have bought it in what is really a suburb of that great city. You will be leaving in a few days won't you. How I wish we were going with you.

There are three pressures which are being exerted against me here to none of which, I promise, will I submit. 1—All our local acquaintances want us to climb mountains; 2—Mell wants to get me on a horse; 3—my students want me to teach them how to paint abstract expresionism.

My boss here is Boston, Harvard, and alas a poor cousin of the Fricks. To him I am Yale, Oregon and a cousin of the rabbi of Lodz. We are going next week to Denver where we will lunch at the Harvard Club and then if we are through in time at Montgomery Wards, have cocktails at the Yale Club. We attend parties filled with old dowagers to whom we are polite in the hope of bequests. You think I am making polite litterature [*sic*]. This is more realistic than you will ever believe.

Two of my paintings hang here for the last 3 weeks. The silence is thick. Not a word or look from faculty, students, or the Fricks. One of them, on my first visit I found was hung horizontally. I phoned the hanger about this error, "Oh, it

Herbert Ferber Papers, 1932–1987, personal correspondence, microfilm reel N69/133. Archives of American Art, Smithsonian Institution, Washington, D.C.

was no error" he said, "I thought it filled the space better." I swear by the bones of Titian that this is true.

In spite of this being desert, there is some grass here, but it has to be sprinkled every odd day of the month.

Katy is very happy. There are lots of kids. Our love to you and we miss you. Please write

Mark

Letter to Lawrence Calcagno, 1956

102 W 54
Jan. 10 1956

Dear Larry Calcagno—

I want to tell you that I am quite upset by the use made of our pictures in the last issue of the Art News. I do want you to know that my photograph was used without my permission and without any knowledge on my part, whatsoever, that any article was being written. I feel equally affronted with you that anything that an artist does with such seriousness should be put to a use which to me seems basically vicious.

I think that this viciousness toward you, specifically, is so transparent and so out of proportion to his treatment of the other painters that it will find little credibility in a thinking mind. This is the only solace I can find in this unhappy incident.

Sincerely
Mark Rothko

Lawrence Calcagno Papers, 1934–1980, microfilm reel N70-43–N70-45. Archives of American Art, Smithsonian Institution, Washington, D.C. Lawrence Calcagno, an American artist (1913–1993), studied in San Francisco with Clyfford Still and Rothko.

Notes from a conversation with Selden Rodman, 1956

Rothko is touchy about his work and not a little secretive. Four years ago he wrote that it is "a risky business" to send a picture "out into the world. How often it must be impaired by the eyes of the unfeeling and the cruelty of the impotent who could extend their affliction universally!" But I was fortunate enough to receive illumination on one point without asking for it all. Our encounter took place at the Whitney Annual which I was visiting with a friend. Suddenly there was Rothko, and he was mad. He was mad at his dealer for having given me permission to reproduce one of his paintings in *The Eye of Man* and, though he was gracious enough not to say so, probably mad at me for having written the book too.

"Janis had no right to give permission," he said, adding that he'd contemplated suing both me and the publisher.

"You should have, Mark," I said, laughing, "you should have. That would have given abstract expressionism far more publicity than I ever could!"

"You might as well get one thing straight," he said, relaxing, "I am not an abstractionist."

"You are an abstractionist to me," I said. "You're a master of color harmonies and relationships on a monumental scale. Do you deny that."

"I do. I'm not interested in relationships of color or form or anything else."

"Then what is it you're expressing?"

"I'm interested only in expressing basic human emotions—tragedy, ecstasy, doom and so on—and the fact that lots of people break down and cry when confronted with my pictures shows that I *communicate* those basic human emotions. I communicate them more directly than your friend Ben Shahn, who is essentially a journalist with, sometimes, moderately interesting in surrealist overtones. The people who weep before my pictures are having the same reli-

Reprinted from Selden Rodman, *Conversations with Artists* (New York: Devin-Adair, 1957), 92–94.

gious experience I had when I painted them. And if you, as you say, are moved only by their color relationships, then you miss the point!"

We parted amicably, but he made it clear that he did not wish to be interviewed further. I was pleased he said as much as he had.

Letter to Herbert Ferber, March 18, 1957

18th March 1957
510 Iona St.
Metairie,
New Orleans

Dear Fellows—Herbert Ilsa & [indecipherable]—
I will start out by telling you that we miss you. One needs a glimpse of elsewhere and others, to know how blessed it is to be set in New York, and how tailor made and unique are the few friends that have percolated down in the passing years.

We are attending a lecture by St[indecipherable] tonight and a party tonight afterward. Tho we wrote him ten days ago inviting him to stay with us, we have not heard a word directly, but we know that he is driving down today from Biloxi where he spent the weekend with Dusti Bongé. Blenken is coming toward the weekend, so that it will be old home week.

We have been ensconced in a suburb called Metairie, which is an exact equivalent of plush Westchester. We have a house, a garden of proportions, manicured lawns and manicured neighbors. Symbolic of our style is our shower stall which has seven powerful needle sprays and which we have named the "Iron Maiden." We are being dined and wined by these same neighbors whose wives have the restless itch and have glued their souls to the University art department. I weep for us and their husbands more. If there were any doubts, we can say firmly now that these represent the lowest point of civilization anywhere and anytime, and here lie the poisons by which empires destroy themselves.

We have been fortunate in weather. There have been a number of benign days of early summer, sun, warmth and lush growth. In March this alone justifies

Herbert Ferber Papers, 1932–1987, personal correspondence, microfilm reel N69/133. Archives of American Art, Smithsonian Institution, Washington, D.C. Rothko wrote this letter from Tulane University, where he was an artist in residence in February–March 1957.

our venture, as well as the fact that distance has lulled all problems and irritations, as if they were not to reappear in full force in three weeks from now. In great measure we are even enjoying the tearing about socially. The experience is new, revealing, is rather sad in relation to the people whom we judge so harshly.

We get to the French Quarter which is in part like a miniature of a section of Paris with its intense charm of scale and affords all the pleasure of walking and browsing around in. We have also had a glimpse of the plantation country. We shall tell you all in a short while.

Kate attends school half days, and occasionally she is invited to spend afternoons with school mates. People are kind and gracious.

St[indecipherable] just called and we are off to lunch to the French Quarter. Why don't you come along. Our best love—

Mark

Letter to Rosalind Irvine, April 9, 1957

Sp. delivery
April 9, 1957

Miss Rosalind Irvine
WHITNEY MUSEUM OF ART
22 West 54th Street
New York, N.Y.

Dear Miss Irvine:
I am addressing this letter to you in regard to our conversation of yesterday.

I have grappled with the problem for an entire month since Mr. Hermon More spoke to me. As much as I would like to do so, I am unable to submit a picture to your committee.

Please forgive me if I tread upon sensibilities, since I have no wish to do this, and this is the most painful part to me in this decision.

However, this is deeply rooted in my thinking, and I must act accordingly in the interest of the paintings which I still hope to paint.

Sincerely,
Mark Rothko
104 W. 61st St. (studio)

Whitney Museum of American Art Artists' Files and Records, 1914–1966, Artist File on Mark Rothko, microfilm reel N683. Archives of American Art, Smithsonian Institution, Washington, D.C. Irvine was associate curator at the Whitney.

Letter to the editor, 1957

Re: Two Americans in Action (A. N. Annual, '58)

I reject that aspect of the article which classifies my work as "Action Painting." An artist herself, the author must know that to classify is to embalm. Real identity is incompatible with schools and categories, except by mutilation.

To allude to my work as Action Painting borders on the fantastic. No matter what modifications and adjustments are made to the meaning of the word action. Action Painting is antithetical to the very look and spirit of my work. The work must be the final arbiter.

Mark Rothko
New York, N.Y.

Art News, 56, no. 8 (December 1957): 66, in response to Elaine de Kooning, "Two Americans in Action: Franz Kline and Mark Rothko," *Art News Annual* 27 (1958): 86–97, 174–179. This article described Kline and Rothko as "action painters," a designation that Rothko absolutely refused to accept.

Address to Pratt Institute, November 1958

I began painting rather late in life; therefore my vocabulary was formed a good time before my painting vocabulary was formed, and it still persists in my talking about painting. I would like to talk about painting a picture. I have never thought that painting a picture has anything to do with self-expression. It is a communication about the world to someone else. After the world is convinced about this communication it changes. The world was never the same after Picasso or Miró. Theirs was a view of the world which transformed our vision of things. All teaching about self-expression is erroneous in art; it has to do with therapy. Knowing yourself is valuable so that the self can be removed from the process. I emphasize this because there is an idea that the process of self-expression itself has many values. But producing a work of art is another thing and I speak of art as a trade.

The recipe of a work of art—its ingredients—how to make it —the formula.

1. There must be a clear preoccupation with death—intimations of mortality. . . . Tragic art, romantic art, etc., deals with the knowledge of death.
2. Sensuality. Our basis of being concrete about the world. It is a lustful relationship to things that exist.
3. Tension. Either conflict or curbed desire.
4. Irony. This is a modern ingredient—the self-effacement and examination by which a man for an instant can go on to something else.
5. Wit and play . . . for the human element.

Rothko's papers. This transcription of a recorded conference that Rothko gave at Pratt Institute, accompanied by questions from the audience and Rothko's answers, is the reproduction of this text in its entirety. According to Dore Ashton, who attended this conference and published the article "Art: Lecture by Rothko," *New York Times*, October 31, 1958, Rothko did not read from notes during the conference. See also Dore Ashton, *About Rothko* (New York: Oxford University Press, 1983), 44.

6. The ephemeral and chance . . . for the human element.

7. Hope. 10% to make the tragic concept more endurable.

I measure these ingredients very carefully when I paint a picture. It is always the form that follows these elements and the picture results from the proportions of these elements.

I want to mention a marvelous book: Kierkegaard's *Fear and Trembling*, which deals with the sacrifice of Isaac by Abraham. Abraham's act was absolutely unique. There are other examples of sacrifice: in the Greek, the Agamemnon story (state or daughter); also Brutus who had both of his sons put to death. But what Abraham did was un-understandable; there was no universal law that condones such an act as Abraham had to carry out. As soon as an act is made by an individual, it becomes universal. This is like the role of the artist. Another problem of Abraham was whether to tell Sarah. This is a problem of reticence. Some artists want to tell all like at a confessional. I as a craftsman prefer to tell little. My pictures are indeed facades (as they have been called). Sometimes I open one door and one window or two doors and two windows. I do this only through shrewdness. There is more power in telling little than in telling all. Two things that painting is involved with: the uniqueness and clarity of image and how much does one have to tell. Art is a shrewdly contrived article containing seven ingredients combined for the utmost power and concreteness.

The problem of the civilization of the artist. There has been an exploitation of primitiveness, the subconscious, the primordial. This has affected our thinking. People ask me if I am a Zen Buddhist. I am not. I am not interested in any civilization except this one. The whole problem in art is how to establish human values in this specific civilization.

I belong to a generation that was preoccupied with the human figure and I studied it. It was with the most reluctance that I found that it did not meet my needs. Whoever used it mutilated it. No one could paint the figure as it was and feel that he could produce something that could express the world. I refuse to mutilate and had to find another way of expression. I used mythology for a while, substituting various creatures who were able to make intense gestures without embarrassment. I began to use morphological forms in order to paint gestures that I could not make people do. But this was unsatisfactory.

My current pictures are involved with the *scale* of human feelings the human drama, as much of it as I can express.[52]

52. Rothko's statement ends here. Questions from the audience and Rothko's answers follow.

Q. Don't you feel that we have made a new contribution in terms of light and color, ambience?

A. I suppose we have made such a contribution in the use of light and color, but I don't understand what ambience means. But these contributions were made in relation to the seven points. I may have used colors and shapes in the way that painters before have not used them, but this was not my purpose. The picture took the shape of what I was involved in. People have asked me if I was involved with color. Yes, that's all there is, but I am not against line. I don't use it because it would have detracted from the clarity of what I had to say. The form follows the necessity of what we have to say. When you have a new view of the world, you will have to find new ways to say it.

Q. How does wit and play enter your work?

A. In a way my paintings are very exact, but in that exactitude there is a shimmer, a play . . . in weighing the edges to introduce a less rigorous, play element.

Q. Death?

A. The tragic notion of the image is always present in my mind when I paint and I know when it is achieved, but I couldn't point it out, show where it is illustrated. There are no skill and bones. (I am an abstract painter.)

Q. On philosophy?

A. If you have a philosophical mind you will find that nearly all paintings can be spoken of in philosophical terms.

Q. Shouldn't the young try to say is all . . . question of control?

A. I don't think the question of control is a matter of youth or age. It is a matter of decision. The question is: is there anything to control. I think that a freer, wilder kind of painting is not more natural with youth than with gray old men. It isn't a question of age; it is a question of choice. This (idea) has to do with fashion. Today, there is an implication that a painter improves if he gets more free. This has to do with fashion.

Q. Self-expression . . . communication versus expression. Cannot they be reconciled? Personal message and self-expression.

A. What a personal message means is that you have been thinking for yourself. It is different from self-expression. You may communicate about yourself; I prefer to

communicate a view of the world that is not all of myself. Self-expression is boring. I want to talk of nothing outside of myself—a great scope of experience.

Q. Can you define Abstract Expressionism?

A. I never read a definition and to this day I don't know what it means. In a recent article I was called an action painter. I don't get it and I don't think my work has anything to do with Expressionism, abstract or any other. I am an antiexpressionist.

Q. Large pictures?

A. Habit or fashion. Many times I see large pictures whose meaning I do not understand. Seeing that I was one of the first criminals, I found this useful. Since I am involved with the human element, I want to create a state of intimacy—an immediate transaction. Large pictures take you into them. Scale is of tremendous importance to me—human scale. Feelings have different weights; I prefer the weight of Mozart to Beethoven because of Mozart's wit and irony and I like his scale. Beethoven has a farmyard wit. How can a man be ponderable without being heroic? This is my problem. My pictures are involved with these human values. This is always what I think about it. When I went to Europe and saw the old masters, I was involved with the credibility of the drama. Would Christ on the cross if he opened his eyes believe the spectators? I think that small pictures since the Renaissance are like novels; large pictures are like dramas in which one participates in a direct way. The different subject necessitates different means.

Q. How can you express human values without self-expression?

A. Self-expression often results in inhuman values. It has been confused with feelings of violence. Perhaps the word *self-expression* is not clear. Anyone who makes a statement about the world must be involved with self-expression but not in stripping yourself of will, intelligence, civilization. My emphasis is upon deliberateness. Truth must strip itself of self which can be very deceptive.

Letter to Ida Kohlmeyer, ca. 1958

Dear Kohlmeyers—

Enclosed a check for $130, five dollars of which covers long distance calls; and the rest, as we understood the arrangement, for rent. If there is anything else that we must account for, please tell us. Thank you again, very much, for making the house available to us.

Mark Rothko

Archives of American Art, Smithsonian Institution. Ida Kohlmeyer (1912–1997), a painter and sculptor, met Rothko when he was visiting artist at Newcomb Art School, Tulane University, New Orleans. While at Tulane the Rothkos lived in Metairie, a suburb of New Orleans. Apparently they rented a house from Ida Kohlmeyer.

John Fischer, "The Easy Chair: Mark Rothko, Portrait of the Artist as an Angry Man," 1970

In the Spring of 1959 Mark Rothko was famous but not yet rich. He also was tired from eight months of labor—nine to five everyday—on a set of murals, the biggest commission he had ever received. He was not satisfied with the way the work was going, so in June he took off for a rest and a change of scene. With his wife and eight-year-old daughter he headed for Naples, traveling tourist class on the USS *Constitution*.

After dinner on the first night out of New York he wandered into the tourist class bar looking for someone to talk to.

Talk, as I later found, was a necessity for him, like breathing. As it happened, I was the only other person in the bar: everybody else was up in the lounge at one of those jolly shipboard get-togethers, which I had long since learned to avoid. Rothko peered around the room through his thick-lensed glasses, then ambled over to my table with his characteristic elephantine gait. He introduced himself, and began a conversation which continued—intermittently and with long lapses —until he killed himself last February. At the time of his death I had not seen him for several years, but I had taken it for granted that we would meet again any day now and that he would pick up the talk where it had broken off. So the news brought me a special sense of loss, as if an engrossing story had been interrupted in the middle and now could never be completed.

During our first few minutes in the ship's bar Rothko probed to see whether I knew anything about the art world. When he assured himself I did not —that I had no acquaintanceship whatever among fashionable painters, critics, dealers, museum curators, or collectors—he began to talk freely about his own

Reprinted with permission from *Harper's*, July 1970, 16–23. The writer John Hurt Fischer met Rothko during a trip to Europe in the spring of 1959. He took notes during his conversations with Rothko, which were not published until 1970.

work. He would never have done so, as he told me later, if I had had even a tenuous connection with the *cognoscenti*: for such people he distrusted.

I had never met anybody like him. Consequently, when I got back to my stateroom long after midnight, I made notes on what he has said—as I did on subsequent occasions. I am transcribing some of them here in hopes that they might provide a useful footnote to the history of contemporary art.

Rothko first remarked that he had been commissioned to paint a series of large canvases for the walls of the most exclusive room in a very expensive restaurant in the Seagram building—"a place where the richest bastards in New York will come to feed and show off."

"I'll never tackle such a job again," he said. "In fact, I've come to believe that no painting should ever be displayed in a public place. I accepted this assignment as a challenge, with strictly malicious intentions. I hope to paint something that will ruin the appetite of every son of a bitch who ever eats in that room. If the restaurant would refuse to put up my murals, that would be the ultimate compliment. But they won't. People can stand anything these days."

To get the oppressive effect he wanted, he was using a "dark palette, more somber than anything I've tried before."

"After I had been at work for some time," he said, "I realized that I was much influenced subconsciously by Michelangelo's walls in the staircase room of the Medicean Library in Florence. He achieved just the kind of feeling I'm after —he makes the viewers feel that they are trapped in a room where all the doors and windows are bricked up, so that all they can do is butt their heads forever against the wall.

"So far I've painted three sets of panels for this Seagram job. The first one didn't turn out right, so I sold the panels separately as individual paintings. The second time I got the basic idea, but began to modify it as I went along—because, I guess, I was afraid of being too stark. When I realized my mistake, I started again, and this time I'm holding tight to the original conception. I keep my malice constantly in mind. It is a very strong motivating force. With it pushing me, I think I can finish off the job pretty quickly after I get home from this trip."

As things turned out, the murals were far from finished, and they were never hung in the dining room which he so despised.

His verbal ferocity was at first hard to take seriously, because Rothko looked anything but malicious. He was sipping a Scotch and soda with obvious gusto: he had the round, beaming face and comfortably plump body of a man who enjoys his food: and his voice sounded almost cheerful. Never, then or later,

did I ever see him display any outward sign of anger. His affection for Mell, his wife, and Katie, their daughter, was touchingly obvious: and with his friends he was more companionable and considerate than most people I have known. Yet somewhere inside he did nurse a small, abiding core of anger—not against anything specific, so far as I could tell, but against the sorry state of the world in general, and the role it now offers to the artist.

He had been nursing it for a long time, ever since he was a boy growing up in Portland, Oregon. His father, a pharmacist, had moved from Russia when Rothko was ten years old, and the youngster never was able to forgive this transplantation to a land where he never felt entirely at home. Although he spoke little about his parents, I gathered that they were political radicals, like many Russian emigrants of that time. At any rate, Rothko "grew up as an anarchist, long before I could understand what politics was all about."

"While I was still in grade school," he said, "I listened to Emma Goldman[53] and to the IWW[54] orators who were plentiful on the West Coast in those days. I was enchanted by their naïve and childlike vision. Later, sometime in the Twenties I guess, I lost all faith in the idea of progress and reform. So did all my friends. Perhaps we were disillusioned because everything seemed so frozen and hopeless during the Coolidge and Hoover era. But I am still an anarchist. What else?"

A few times during our eight-day voyage I ventured a tentative remark about current politics, in which I was then deeply involved as a minor henchman and speech writer for Adlai Stevenson.[55] Rothko made no effort to conceal his boredom. Formal religion bored him too, as he made plain when we were joined from time to time by a priest, Father Joseph Moody, who also took refuge in the tourist-class bar most evenings. Invariably the conversation soon drifted around to the world of the artist, and his enemies.

Here, for example, are my notes on the Rothko view of critics:

"I hate and distrust all art historians, experts, and critics. They are a bunch of parasites, feeding on the body of art. Their work not only is useless, it is misleading. They can say nothing worth listening to about art or the artist, aside from personal gossip—which I grant you can sometimes be interesting."

Two of his special hates were Emily Genauer, who had described his paintings in a *New York Herald Tribune* article as "primarily decorations"—to him the ultimate insult—and Harold Rosenberg, whom he regarded as "pompous."

53. Emma Goldman (born in Lithuania, 1869; died in Chicago, 1940), feminist and anarchist.
54. IWW: the union organization Industrial Workers of the World.
55. Adlai Ewing Stevenson (1900–1965), politician and diplomat, was a United States ambassador to the United Nations and a Democratic candidate for president.

"Rosenberg," he said, "keeps trying to interpret things he can't understand and which can't be interpreted. A painting doesn't need anybody to explain what it is about. If it is any good, it speaks for itself, and a critic who tries to add to that statement is presumptuous."

If he had still been around to read it, I think Rothko would have regarded Rosenberg's elegiac interpretation of his work in *The New Yorker* last March 28 as a case in point.

In addition to critics, Rothko detested "the whole machine for the popularization of art—universities, advertising, museums, and the Fifty-seventh Street salesmen."

"When a crowd of people looks at a painting, I think of blasphemy, I believe that a painting can only communicate directly to a rare individual who happens to be in tune with it and the artist."

For this reason, he generally refused to lend his pictures for group exhibits. (Also I suspect, he disliked having them shown in the company of artists he disdained.) He was, however, going along with the plans of the Museum of Modern Art to give him a one-man show—although he did not exempt MoMA from his general condemnation of museums.

"I want to be very explicit about this," he said, "They need me. I don't need them. This show will lend dignity to the Museum. It does not lend dignity to me."

Why was he so bitter about the Museum of Modern Art? "Because it has no convictions and no courage. It can't decide which paintings are good and which are bad. So it hedges by buying a little of everything."

Nevertheless, when the Museum opened his exhibition in 1961 with a private showing for invited guests, he gave every sign of being pleased with the occasion. For all his gregariousness, he was shy: and since he was on display as much as his paintings, he began the evening in an agony of stage fright. Later, as one guest after another came to congratulate him—and usually to express an almost reverent admiration for his work—he relaxed and started to glow with affability, even when he was talking to a curator or critic. His ego, like everybody else's, evidently was not indifferent to homage.

Rothko's attitude toward his own work, as expressed during our shipboard talks and later, occasionally struck me as contradictory. He insisted that a painting ought to be savored only by that "rare individual" who really could appreciate it, in the privacy of his own home. Yet his canvases, at least in the later period for which he became famous, were so large—and so expensive—that they could be displayed only in museums, or in homes with lots of costly wall space. As an anarchist, he disapproved of the wealthy and questioned their taste; but his pictures

seemed designed to end up in their hands. Moreover, he repeatedly remarked that "no picture can be judged by itself." Everything an artist produces, he believed, was a part of his continuous development, and therefore his entire output should be regarded as a single whole. This view, it seemed to me, implies a museum or a private collection large enough to keep at least a substantial sequence of a painter's work on permanent display. Ah, well, if some contradictions lurk here, never mind. Nobody has a right to insist that an artist be consistent.

Once I asked him a silly question: What did he think his pictures were worth?

"Whatever I can get for it," he said. "Fifteen years ago I was lucky to sell a canvas for sixty dollars. Today my price is six thousand or better. Tomorrow it may be six hundred."

Like most people who grew up during the Depression, and worked long years for small return, Rothko was keenly aware of the value of money. One day in 1961 he asked my wife and me to meet him in his studio for a drink, before going on to his apartment for dinner. The studio was a converted gymnasium in what once had been a YMCA on the Bowery. Inside it he had erected a scaffold of the exact dimensions of that dining room in the Seagram building, for which he supposedly was painting the murals. He still had not been able to finish them to his satisfaction, and on the day of our visit he had turned away from them to work on another canvas. It was typical of his later work: a rectangle of about 9 by 14 feet, covered with a solid color over which he had painted three smaller rectangles in contrasting colors.

"This kind of design may look simple," he said, "but it usually takes me many hours to get the proportions and colors just right. Everything has to lock together. I guess I am pretty much of a plumber at heart."

Big racks built along one side of the studio, and in adjoining quarters which apparently had been the gymnasium dressing room, were stacked full of similar outsize paintings—at a quick estimate, several dozens of them. "I can't afford to put them in the market just now," he explained. "This year I already have to pay too much income tax. And if my prices hold up, I can probably get more for them next year anyhow."

He added that he was a little nervous about holding them indefinitely, because he well knew—and resented—the speed with which fashions shift in the New York art market. Sometimes he spoke as if every painter, and every school of painting, were locked in mortal competition with every other. He thought of himself as belonging to a group which included Motherwell, Klein, Still and de

Kooning, all of whom he respected. He had nothing but contempt, however, for Kandinsky and for Ben Shahn[56] — "a kind of cheap propagandist."

"Nobody can deny," he once said, "that my group accomplished one thing. We destroyed cubism. Nobody can paint a cubist picture today. But we didn't destroy Picasso—he is still valid."

I couldn't resist asking him whether he had any idea who the young painter might be who eventually would destroy Rothko & Co. "If I did, I would kill him," he said. He sounded as if he meant it.

A moment later, he added that he had no doubt such a destroyer would come along sooner or later. "The kings die today in just the same way they did Fraser's *Golden Bough*."

According to his account, Rothko became a painter almost by accident. He had dropped out of Yale in 1923, after a couple of years of liberal arts, and moved to New York with no clear idea of what to do with his life.

"Then one day," he said, "I happened to wander into an art class, to meet a friend who was taking the course. All the students were sketching this nude model—and right away I decided that was the life for me."

For a short time he attended Max Weber's class at the Art Students League and then—when he got bored with nude models—he launched out on his own. For years he painted realistic pictures, and what critics later were to describe as paintings with expressionist and surrealist tendencies. None of these experiments brought him either fame or much money, so he turned for two years during the Depression to work with the WPA Federal Arts Project in New York. Only about 1947 did he develop a style which caught the attention of important critics and patrons—among them Peggy Guggenheim—and from then on his rectangles floating in colored space found a growing market, first through the Betty Parsons and then the Sidney Janis galleries. By the early Sixties he was widely regarded as one of the country's half-dozen leading painters.

My wife once told him that she thought he must be a mystic, because his paintings conveyed, to her at least, a sense of magic and ritual, verging on the religious. He denied it.

"Not a mystic. A prophet perhaps—but I don't prophesy woes to come. I just paint the woes already here."

Even I could see that, in the unfinished Seagram Murals. In their latter stage the color masses—purple and black and a red like dried blood—breathed

56. Ben Shahn (1898–1969), principal representative of the social realist style in the United States during the 1930s.

an almost palpable feeling of doom. And, in spite of his denial, an almost religious mysticism. Peter Selz of the Museum of Modern Art described them as "celebrating the death of a civilization . . . their subject might be death and resurrection in classical, not Christian mythology . . . a modern Dance of Death."

In the end Rothko apparently came around to a similar conclusion. He decided that this series of canvases, on which he had spent so much labor and emotion, amounted to a good deal more than a malicious gesture to rich gourmands, and deserved a better setting than a fashionable dining room. Not long before his death he arranged for them to be hung in a building created especially for them — a nondenominational chapel in Houston, built to his specifications and commissioned by the de Menil family.

Only twice in my hearing did he hint that his work might be an expression of some deeply hidden religious impulse.

At the end of that 1959 voyage, his family and mine both stayed for a few days in and around Naples to see usual tourist sights, sometimes separately, sometimes in company. After he had visited Pompeii, he told me that he had felt a "deep affinity" between his own work and the murals in the House of Mysteries — "the same feeling, the same broad expanses of somber color."

Our two families went together on a day-long expedition to Paestum, the site of an ancient Greek colony which contains the ruins of three of the most interesting temples this side of Athens. (During World War II Paestum was taken by American troops as part of the Salerno beachhead, and the Temple of Neptune was commandeered for a headquarters and communications center. It is a miracle that it was not destroyed by the German Artillery on the hills surrounding the battlefield.)

On our early morning train ride south from Naples, two Italian boys on holiday from high school struck up an acquaintance with my teen-age daughters, and presently decided to join our party. They would be glad, they said, to serve us as guides — although the arrangement was a little awkward, since they spoke no English and none of us spoke Italian. Our group conversation, such as it was, had to be carried on in French, which they spoke imperfectly and which my elder daughter, Nic, managed only a little better.

The ruins turned out to be even more awesome that the guidebooks had led us to expect. We wandered through them all morning; Rothko examined every architectural detail with bemused attention, rarely saying a word. At noon I picked up some bread, cheese, and a bottle of wine at a nearby grocery and all of us settled down in a shady patch inside the shell of the Temple of Hera for a pic-

nic lunch. Nic hardly got a bite, because she was busy trying to interpret the boys' questions. Who were we? What were we doing there?

Turning to Rothko she said, "I have told them that you are an artist, and they ask whether you came here to paint the temples." "Tell them," he said, "that I have been painting Greek temples all my life without knowing it."

This is pure speculation, but I suspect Rothko's death may have been related to the fact that artists these days are not encouraged to paint temples.

For centuries, of course, that was one of their main functions. Art was intimately connected with religion, in such places as the House of Mysteries and later in the churches and monasteries of Byzantium and Europe. The great artists of the Middle Ages and the Renaissance were largely preoccupied with teaching the lessons of the Bible to the illiterate, by means of fresco, mosaic, portraits, sculpture, stained glass—the visual aids of their time. The Church was their chief patron. Their role in society was explicit and secure. Their work was both necessary and honorable: indeed, almost holy since it was recognized as God's work.

Gradually, this function diminished, with the invention of the printing press, the decline of religion, and finally the advent of the camera. By the twentieth century artists were no longer performing a unique role: the creation of images which filled a deeply felt need of their culture, and which they alone could provide. Inevitably many people began to regard their work as "primarily decorative"—a cosmetic of society rather than food for its soul.

Recently the artist has been assigned a still more demeaning role: the production of artifacts which can be exploited by the art world—that is, the dealers, the critics, fashionable collectors, and speculators. Even a mutual investment trust, the Fine Arts Fund, recently has been organized to deal in such artifacts; its managers obviously have no interest in the artist's message, but only in his appreciation potential. Will a Warhol rise in price faster than a Rothko?

Such a question can infuriate a man like Rothko. So too can the judgement of a critic such as John Canaday, in his review of Rothko's Museum of Modern Art show. He commented that, to a large degree, "the painter today has become a man whose job it is to supply material in progressive stages for the critic's aesthetic exercises. This is a distressing cart-before-the-horse relationship, but it has its legitimacy—no question about that—in a day when other arts supply most of the needs that painting used to supply, and leave painting only its more esoteric functions. In such a situation it is quite natural that the critic may be tempted to find most in the painter who says least, since that painter leaves most room for aesthetic legerdemain."

Rothko, I believe, deeply resented being forced into the role of a supplier of "material" either for investment trusts of for aesthetic exercises. I have heard several explanations of his suicide—that he had been in ill health, that he had been unproductive for the last six months, that he felt rejected by an art world which had switched its momentary fancy to younger and inferior painters. There may be something in all of them; I don't know. But I have a hunch that at least a contributing cause was his long anger: the justified anger of a man who felt destined to paint temples, only to find his canvases treated as trade goods.

Letter to Herbert Ferber and Bernard Reis, June 11, 1959

MARK AND MARY ALICE ROTHKO

102 West 54th Street

New York, N.Y.

June 11, 1959

Mr. and Mrs. Herbert Ferber

454 Riverside Drive

New York, N.Y.

Mr. Bernard J. Reis

252 East 68th Street

New York 21, N.Y.

Dear Friends:

We have just made wills which provide that in case of our death and Kate's, you are to be the Executors. Our estates will be divided as set forth in our wills. The principal item in the estates, of course, is the inventory of paintings, and it is our wish that the pictures should be sold as follows:

Herbert Ferber Papers, 1932–1987, personal correspondence, microfilm reel N69/133. Archives of American Art, Smithsonian Institution, Washington, D.C. An art collector, Bernard Reis was the adviser to Peggy Guggenheim. He helped finance the *Surrealist Journal*, of which he was treasurer. Rothko met him in 1948, during the creation of the school The Subjects of the Artist (see note 14 in the Introduction, this volume). In 1958 Rothko signed an agreement with Reis to represent him in negotiations with the gallery owner Sydney Janis. Reis advised Rothko legally during the time when Marcus Rothkowitz officially changed his name to Mark Rothko in 1959. At the beginning of the 1960s, Reis became Rothko's financial adviser and accountant as well as his lawyer. He helped Rothko in his negotiations with the Menil family and the Marlborough Gallery. In September 1968 Reis prepared Rothko's will. In the will dated 1968, Reis (with Theodoros Stamos and Morton Levine) is named executor of Rothko's estate in case of the deaths of Rothko and his wife, Mell. Reis also became one of the six directors of the Mark Rothko Foundation. After Rothko's suicide, Reis betrayed the painter and his heirs: he sold some of Rothko's works to the Marlborough Gallery, for which he was the accountant.

a) The museum or individual who will acquire the largest number to be held in a single place should be given preference;

b) To museums outside of New York City and in Europe which will acquire at least six paintings;

c) To museums or individuals who will acquire at least three paintings;

d) These conditions for distribution should be adhered to for a period of five years.

With thanks, I am

Sincerely,
Mark Rothko
Mary Alice Rothko

Letter to Elise Asher and Stanley Kunitz, July 1959

Dear Folks

I write this in the Luxembourg gardens sipping beer, while Mell & Kate watch the marionettes. This morning St. Chapelle & Notre Dame. And we live at the Quai Voltaire overlooking the Seine and Louvre. So you see, things are exactly as they should be.

 In Venice we found your pink letter which illumined our day like the stained glass wonders here around. There we saw San Marco, P. Guggenheim, Gregory Corso and John Meyers. Also at night we followed in a gondola the musical barge up and down the great canal.

 And all of this is relaxing and very unreal.

 What I want to say is that we miss you and think of you tending garden, your poems and your pictures. We have now entered the second month of our trip and will see you soon.

 Mark
 Our love to the Bultmans, to Franz & Betsy and no sign here of
Bill De Kooning

Elise Asher Papers, 1923–1994, series 2: Letters, 1941–1988, box 1, microfilm reel 4938. Archives of American Art, Smithsonian Institution, Washington, D.C. Elise Asher (1912–2004) was a painter and the wife of the poet Stanley Kunitz.

Letter to Milton Avery, 1960

102 W 54

Dear Milton—

I don't know how you feel about fan mail; but since you are not here, I must write and say again what a great artist you are.

I hope that you are feeling tops and that you and Sally are having a wonderful time.

Mark

Milton Avery Papers, 1927–1982, microfilm reel N69-63. Archives of American Art, Smithsonian Institution, Washington, D.C.

Notecards, ca. 1950 – 1960

COLOR

addition to experienced color and space

Once color is out of the paint can, it is seen in the world of human action in relation to the time and the event of the day and the eyes for whom the time and events occur.

I use colors that have already been experienced thru the light of day and thr[u] the states of mind of the total man. In other words my colors are not colors that are laboratory tools which is isolated from all accidentals and impurities so that they have a specified identity or purity.

"WHEN I SAY . . . "

When I say that my paintings are Western, what I mean is that they seek the concretization of no state that is without the limits of western reason, no esoteric, extra-sensory or divine attributes to be achieved by praying & terror. Those who can claim that these are exceeded are exhibiting self imposed limitation as to the tensile limits of the imagination within those limits. In other words, that there is no yearning in these paintings for Paradise, or divination. On the contrary they are deeply involved in the possibility of ord[inary] humanity.

SPACE

From that point of view, that is from the largest and concrete meaning that such words have for us in an unspecialized use, that is in its roughest and most general use in the vernacular (and it is only in the vernacular it seems to me that words have their real meaning) the word space is correct.

Among Rothko's papers there are a dozen notecards. I have included five in which the thoughts seem most developed.

As pertaining to my pictures, or rather in the terms of pictorial space the word seems to me inaccurate and misleading. For the meaning that the word has in the discussion of pictures is that of a medium either realistically or symbolically indicated in which the drama of volume or motion or both take place.

EDUCATION

Education is not in regard to what things really are. It is a presentation not only [of] what the educator decides should be known, but also a decision by which categories, what context and to what social purpose. All being antagonistic to art whose aim it is always to repudiate the seeing the world in parts and by categories and to reestablish the vision of a whole person.

APOLLO

Apollo may be the God of Sculpture. But in the extreme he is also the God of Light and in the burst of splendor not only is all illumined but as it gains in intensity all is also wiped out. That is the secret which I use to contain the Dionisian in a burst of light.

Letter to the Whitechapel Gallery, 1961

*Suggestions from Mr. Rothko regarding installation of his paintings at the
Whitechapel Gallery 1961*

WALL COLOR: Walls should be made considerably off-white with umber and
warmed by a little red. If the walls are too white, they are always fighting against the
pictures which turn greenish because of the predominance of red in the pictures.

LIGHTING: The light, whether natural or artificial, should not be too strong: the
pictures have their own inner light and if there is too much light, the color in
the picture is washed out and a distortion of their look occurs. The ideal situation
would be to hang them in a normally lit room—that is the way they were painted.
They should not be over-lit or romanticized by spots; this results in a distortion
of their meaning. They should either be lighted from a great distance or indirectly
by casting lights at the ceiling or the floor. Above all, the entire picture should
be evenly lighted and not strongly.

HANGING HEIGHT FROM THE FLOOR: The larger pictures should all be hung as
close to the floor as possible, ideally not more than six inches above it. In the
case of the small pictures, they should be somewhat raised but not "skyed"
(never hung towards the ceiling). Again this is the way the pictures were painted.
If this is not observed, the proportions of the rectangles become distorted and
the picture changes.

The exceptions to this are the pictures which are enumerated below which were
painted as murals actually to be hung at a greater height. These are:

 1 Sketch for Mural, No 1, 1958
 2 Mural Sections 2, 3, 4, 5, and 7, 1958–9
 3 White and Black on Wine, 1958

Whitechapel Art Gallery Archive, London.

The murals were painted at a height of 4' 6" above the floor. If it is not possible to raise them to that extent, any raising above three feet would contribute to their advantage and original effect.

GROUPING: In the Museum of Modern Art's exhibition all works from the earliest in the show of 1949 inclusive were hung as a unit, the watercolors separated from the others. The murals were hung in a second unit, all together. The only exception to this grouping of the murals is the picture owned by Mr. Rubin, "White and Black on Wine" 1958, which could take its place, but with a raised hanging among the works since it is a transitional piece between the earlier pictures of that year and the mural series. In the remaining works, it is best not to follow a chronological order but to arrange them according to their best effect upon each other. For instance, in the exhibition at the Museum the very light pictures were grouped together—yellows, oranges, etc.—and contributed greatly to the effect produced.

In considering your installation, it might be of interest that with three murals (Mural Section No 3, 1959 in center, Mural Section No 5, and Mural Section No 7, each on flanking walls) were hung in a separate gallery in our Museum. The dimensions of this gallery were 16½' x 20' which Rothko felt were very good proportions and gave an excellent indication of the way in which the murals were intended to function. If a similar room could be devised, it would be highly desirable.

ith Mark Rothko," 1961

⟋ ⟍ not look like an artist. At the preview of an exhibition of
⟍ the Whitechapel Art Gallery, he was wearing a sober, dark suit.

He did not like to talk of himself or his work. "You see the pictures. You look at them and think about them. This is what interests me." He is an American.

When he was asked what he thought of our artists, he said: "I do not think in terms of nations. I think in terms of men. From the little that I have seen in this country, I would say that your artists are very much alive and vital. But I do not want to answer these questions."

He hinted that in the midcourse he had changed from figurative painting to his now abstract form because of a need to move on into fresher, more exciting pastures. He said he was a decade older than the late Jackson Pollock and had known him well. He smoked tipped American cigarettes continuously.

General Sir Brian Horrocks was at the preview. Did he like the pictures? "I think they are marvellous, I really do."

Reprinted with permission from *Yorkshire Post* (Leeds), October 11, 1961, 8.

Letter to Herbert Ferber, 1962

Dear Herbert,

Ilse told me that if I write at once I may catch you in Paris. So quickly I will tell you that we have been following your moves, and your adventures from day to day by piecing the bits you write here and there. I hope that by this time something decisive has happened.

My show opens Dec 5th[57] by latest reports which I suspect will find you in England. But do speak to Porter McCray[58] who may be lonely for a face like yours and who knows everything and everyone and may be of help, address: Hotel Vendome, #1 Place Vendome.

Here the grind continues. A few new pictures. Harvard is coming to a conclusion favorably,[59] Bob opens Tuesday, Party afterwards, (do come.) The weather is superb, and overall hangs the shadow of my [indecipherable] and other things.

Ilse has been looking well, and has been here several times at our home and in general active and busy.

Since I am an Englophile I wish I were hopping across the Channel. Do no forget [indecipherable name] at the embassy and my regards to him and all our friends.

And lots of luck for your quest

Mark

Archives of American Art, Smithsonian Institution.

57. *Mark Rothko (48 paintings)*, selected by Peter Selz. France, Paris, Musée d'Arte Moderne de la Ville de Paris, December 5, 1962–January 13, 1963. Exhibition originally shown at MoMA in 1961 and later shown in England, the Netherlands, Belgium, Switzerland, and Italy, as well as France.
58. Porter McCray (1908–2001) was the first director of the International Program at the Museum of Modern Art, from 1952 to 1961.
59. Rothko is referring here to the Harvard murals commissioned by Wasily Leontief, president of the Harvard Society of Fellows, whom Rothko had met through Ferber. Rothko had started on the canvas by the end of 1961.

Tribute to Milton Avery,
January 7, 1965

I would like to say a few words about the greatness of Milton Avery.

This conviction of greatness, the feeling that one was in the presence of great events, was immediate on encountering his work. It was true for many of us who were younger, questioning, and looking for an anchor. This conviction has never faltered. It has persisted, and has been reinforced through the passing decades and the passing fashions.

I cannot tell you what it meant for us during those early years to be made welcome in those memorable studios on Broadway, 72nd Street, and Columbus Avenue. We were, there, both the subjects of his paintings and his idolatrous audience. The walls were always covered with an endless and changing array of poetry and light.

The instruction, the example, the nearness in the flesh of this marvelous man—all this was a significant fact—one which I shall never forget.

Avery is first a great poet. His is the poetry of sheer loveliness, of sheer beauty. Thanks to him this kind of poetry has been able to survive in our time.

This—alone—took great courage in a generation which felt that it could be heard only through clamor, force and a show of power. But Avery had that inner power in which gentleness and silence proved more audible and poignant.

From the beginning there was nothing tentative about Avery. He always had that naturalness, that exactness and that inevitable completeness which can be achieved only by those gifted with magical means, by those born to sign.

There have been several others in our generation who have celebrated the world around them, but none with that inevitability where the poetry penetrated every pore of the canvas to the very last touch of the brush. For Avery was a great

Milton Avery Papers, 1927–1982, microfilm reel N69-63. Archives of American Art, Smithsonian Institution, Washington, D.C. Rothko read this tribute to Avery at his funeral at the New York Society for Ethical Culture.

poet-inventor who had invented sonorities never seen nor heard before. From these we have learned much and will learn more for a long time to come.

What was Avery's repertoire? His living room, Central Park, his wife Sally, his daughter March, the beaches and mountains where they summered; cows, fish heads, the flight of birds; his friends and whatever world strayed through his studio: a domestic, unheroic cast. But from these there have been fashioned great canvases, that far from the casual and transitory implications of the subjects, have always a gripping lyricism, and often achieve the permanence and monumentality of Egypt.

I grieve for the loss of this great man. I rejoice for what he has left us.

Mark Rothko

Letter to Bernard Reis, 1966

Monday 8

Dear Bernard & Becky:

Our vacation is about at an end and we sail Wednesday for home. We dock at New York at 6 A.M. Tuesday the sixteenth. I doubt whether any one from the bank is likely to show up at that time.

London has been rainy and my impression of the Tate dubious. It has become a junk yard.

I like our own Moma. It is something I want to talk to you about. The memory of Italy is glorious. We are looking forward to dinner in our back yard.

Love to both of you

Mark

Bernard J. Reis papers, 1934–1979. Archives of American Art, Smithsonian Institution, Washington, D.C. This letter is written on letterhead from the Ritz Hotel in London.

Letter to Norman Reid, 1966

Dear Norman Reid,

My visit to England had one purpose: to discuss with you in detail, and on location, the disposition and conditions of the gift of some of my pictures to the Tate. This was well understood in our conversations in New York and in the exchange of letters between us. I, therefore, made this visit to London at considerable expense and effort.

Your complete personal neglect of my presence in London, and your failure to provide adequate opportunities for these discussions, poses for me the following question: Was this simply a typical demonstration of traditional English hospitality, or was it your way of indicating to me that you were no longer interested in these negotiations?

I would really like to know.

Sincerely
Mark Rothko

Bernard J. Reis Papers, 1934–1979. Archives of American Art, Smithsonian Institution, Washington, D.C. This letter to Reid, director of the Tate Gallery, was written after Rothko's visit to London in 1966. At the end of the 1960s Rothko donated to the Tate a group of his works, which were to be permanently exhibited in one of the rooms of the museum. The Rothko Room at the Tate Gallery, London, opened May 1970.

Letter to Herbert Ferber, July 7, 1967

address———>852 Arlington Ave.
Berkeley, Cal.
JULY 7th 1967

Dear Herbert—

By this time you must be well on the way to mending. I wish you God speed in the process and hope that you can amuse yourself reading and raising general vocal hell.

As you can see by the letterhead I am now thoroughly ensconced in my own office occupying the chair of Sterling Professor formerly held by Dwight Eisenhower. I have not seen a single student yet, although I occupy my office daily to escape the din at home.

If you saw the workshops provided for sculptors in this huge cartel you would spring out of bed at once and ensconce yourself here for the rest of your life. Literally thousands and thousands of square feet devoted to foundry furnaces, ceramic furnaces, hoists, cranes, lathes, metal cutting machinery, carbon [indecipherable], automatic molders and hundreds of machines and instruments which I cannot name.

I was speaking to some young sculptors teaching here, who confessed that if they left school they would have to form a community guild for no one could privately equip himself any longer after having had these things. I described to them how you began your metal sculpture in a room in which your workshop was separated from your living quarters by a wooden counter.

Herbert Ferber Papers, 1932–1987, personal correspondence, microfilm reel N69/133. Archives of American Art, Smithsonian Institution, Washington, D.C. During the summer of 1967, Rothko taught at the University of California, Berkeley, at the recommendation of Peter Selz. There he met Brian O'Doherty and Barbara Novak, who were professors. From Berkeley he wrote two letters on university letterhead to Herbert Ferber and one to Kunitz and Asher.

Imagine the nerve, I am to have twelve students, six of them sculptors, I shall do what I can to destroy competition.

We have been lucky with the weather. We have rented a mansion with a huge landscaped lawn and a grand piano on the Berkeley hilltops. It is a delightful house. We have also discovered a little lake within 2 miles of our house where we swim instead of the University pool, for I find talking to academics is real labor, and not of love. We have a University car and have hired a student to drive it. All in all it is a fine change.

Heal quickly, don't be blue and we all send our love to you & Edith

Mark

Letter to Herbert Ferber, July 19, 1967

JULY 19th 1967

Dear Herbert & Edith—

I think it would be very nice, Edith, if you got Herbert to dictate a medical report and observations what the world looks like from that miserable hospital window.

Last night the Selzes the O'Daughertys and ourselves went to a topless bar. It was great enough for you to jump out of that bed and come right over.

Otherwise we are quite removed from the world, except for a letters [*sic*] from the Yonkers; from Boulder where they don't seem to be too happy, and from Reinhardt from Rome who has his own magnificent view of the ruins, we have heard nothing.

I gave a seminar last week. At the seminar I was clearly given to understand that near [*sic*] the pace nor the values of our youth were applicable to them. However, what I am doing is visiting the students in their studios and there I find them gentle, cordial, intelligent, willing to listen. But above all I think they want to explain themselves to you, and are grateful that you listen.

This is an episode that I value, for in N.Y. I have not found a way of contact with the young that is as illuminating.

Our house is nice, and each in his separate way is doing well. Lets hear how you people are,

Mark

Herbert Ferber Papers, 1932–1987, personal correspondence, microfilm reel N69/133. Archives of American Art, Smithsonian Institution, Washington, D.C.

Letter to Elise Asher and Stanley Kunitz, 1967

Dear Asher and Kunitz—

This is just to tell you that we think of you, first you, then your paintings & poems, then the splendid garden and your beautiful bay.

We have rented a splendid house, but I do miss faces. I don't think a human being has passed our house on foot since we live there.

For my students here I am an old man with values belonging to a past. However, what I do is visit the students in their studios and I find them respectful with an unexpected gentleness and the threat of Vietnam over them visibly.

We will return home on the 15th of August and will miss you until you return.

This is a change and we are comparatively enjoying it.

Our love,

Mark

Elise Asher Papers, 1923–1994. Archives of American Art, Smithsonian Institution, Washington, D.C.

Acceptance of Yale University honorary doctorate, 1969

I want to thank the University and the awards committee for the honor you have chosen to confer upon me. You must believe me that the acceptance of such honors is as difficult as the problem of where to bestow them.

When I was a younger man, art was a lonely thing: no galleries, no collectors, no critics, no money. Yet it was a golden time, for then we had nothing to lose and a vision to gain. Today it is not quite the same. It is a time of tons of verbiage, activity, and consumption. Which condition is better for the world at large I will not venture to discuss. But I do know that many who are driven to this life are desparately [*sic*] searching for those pockets of silence where they can root and grow. We must all hope that they find them.

Bernard J. Reis Papers, 1934–1979. Archives of American Art, Smithsonian Institution, Washington, D.C. The university's citation of Rothko reads as follows: "As one of the few artists who can be counted among the founders of a new school of American painting, you have made an enduring place for yourself in the art of this Century. Your paintings are marked by a simplicity of form and a magnificence of color. In them you have attained a visual and spiritual grandeur whose foundation is the tragic vein in all human existence. In admiration of your influence, which has nourished young artists throughout the world, Yale confers you the degree of Doctor in Fine Arts."

Chronology

1903

Birth of Marcus Rothkowitz to a cultivated Jewish family, September 25, in Dvinsk, Russia (today it is Daugavpils, Latvia). He is the fourth child of Jacob, a pharmacist, and Anna Goldin Rothkowitz. Marcus studies at a cheder; he is the only member of his family to attend religious school.

1913

During the summer, Marcus, his mother, and his sisters emigrate to the United States. There they join the rest of the family. In 1910 Jacob had immigrated to Portland, Oregon, where one of his brothers was living. Jacob is already ill. In September, Marcus is enrolled in the Failing School in a special class for children of immigrants who do not speak English. These students enroll at the elementary level.

1914

In spring Jacob Rothkowitz dies of colon cancer. In September, Marcus enters the third grade at the Shattuck Elementary School. During the second trimester, he is promoted to the fifth grade.

1918–1921

Marcus enters Lincoln High School. He is interested in the arts, theater, and the classics. He asks to be admitted to Yale and receives a student scholarship. At the end of 1921 he moves to New Haven, Connecticut, to begin his studies at Yale.

1922–1923

Rothkowitz pursues his studies at Yale: philosophy, math, economics, English, French, history, biology, and physics. Uses up his scholarship and begins to work at the linen service of the university in order to pay for his studies. In the autumn of 1923 he leaves Yale without a diploma. Moves to New York, where he visits a

Sources: James E. B. Breslin, *Mark Rothko: A Biography* (Chicago: University of Chicago Press, 1993); Diane Waldman, Chronology, in *Mark Rothko* (London: Thames and Hudson, 1978); Jessica Stewart, Chronology, in Jeffrey Weiss, *Mark Rothko* (New Haven: Yale University Press, 1998).

friend who is studying at the Art Students League: Rothkowitz decides at that point that art is his calling.

1924

Rothkowitz studies at the Art Students League during January and February. Returns for a few months to Portland, where he studies theater with Josephine Dillon, an actress who will soon become Clark Gable's first wife.

1925

Rothkowitz returns to New York, where he settles for good. Fails to receive a scholarship to the American Laboratory Theater. He decides to enroll in the New School of Design, where he studies under Arshile Gorky. In October he enrolls in the Art Students League, where he is the pupil of Max Weber until May 1926. Between 1925 and 1928 he works as an illustrator.

1926

Rothkowitz becomes an official member of the Art Students League, a position he will hold until 1930.

1927

Rothkowitz illustrates the book *The Graphic Bible*. His four months of work pay five hundred dollars. He is not listed as the illustrator of the work and unsuccessfully sues the author and publisher of the work.

1928

Rothkowitz's first participation in an exhibition, organized by Bernard Kafiol, professor at the Art Students League, at the Opportunity Galleries in New York. Among the exhibitors is Milton Avery, a professional artist. Through the efforts of his friend Louis Kaufman, Rothkowitz forms an intimate friendship with Avery and his wife. Avery becomes an important influence. Rothkowitz takes a design class at the Averys'.

1929

Rothkowitz begins to teach art to children twice a week at the Center Academy, an annex of the Brooklyn Jewish Center, where he continues to work until 1952.

1932

Rothkowitz marries Edith Sachar.

1933

In the summer Rothkowitz has his first one-man show, at the Museum of Art in Portland, Oregon. He shows watercolors and drawings, along with works by his

students at the Center Academy. In November he has his first one-man show in New York, at the Contemporary Arts Gallery. He exhibits fifteen oil paintings, mostly portraits, four watercolors, and three charcoal sketches.

1934

Rothkowitz participates in three group shows during the summer at the Uptown Gallery, exhibiting *Sculptress* (a portrait of his wife, Edith), *Woman and Cat*, and *Lesson*. Publishes his first article, "New Training for Future Artists and Art Lovers," in the *Brooklyn Jewish Center Review*. At the end of the year, he becomes a member of the Gallery Secession. In a group show there, he exhibits the canvas *Duet*.

1935

Gallery Secession, New York, "Group Exhibition." Rothkowitz exhibits *Nude*.

The artists associated with Gallery Secession form an independent group known as The Ten, based on the principles of realist painting, the exploration of expressionism and abstraction, and opposition to the conservatism of the artistic landscape of the period. The group meets once a month in the studio of one of the members. Rothko is the secretary.

The Ten organizes its first group show at the Montross Gallery in New York. Rothkowitz shows four works, one of which is *Subway* (1935).

1936

New exhibition of The Ten at the Municipal Art Galleries, New York. Rothkowitz exhibits *Crucifixion* and *The Sea*.

Only exhibition of The Ten in Europe is mounted in Paris, at the Galerie Bonaparte.

Rothkowitz works for the Federal Art Project of the Works Progress Administration (wpa).

Montross Gallery, New York, exhibits The Ten. Rothkowitz shows, notably, *Interior*.

1937

Georgette Passedoit Gallery, New York, exhibits The Ten. Rothkowitz shows *Family*.

1938

Rothkowitz becomes an American citizen.

Second Annual Membership Exhibition: American Artists' Congress Inc., New York. Rothkowitz exhibits *Street Scene*.

The Ten is exhibited at Passedoit Gallery and, as *Whitney Dissenters*, Mercury Galleries, both in New York.

1939

Bonestell Gallery, New York, shows The Ten.

After three years, Rothkowitz stops working for the WPA.

1940

The Ten dissolves as several members begin to show individually.

Neumann Willard Gallery, New York, *New Work by Marcel Gromaire, Mark Rothko, Joseph Solman*. Rothkowitz changes his name for this show, though the change will not be legally registered until 1959.

1941

Riverside Museum, New York, *First Annual Federation of Modern Painters and Sculptors Exhibition*. Rothko exhibits *Underground Fantasy* and *Subway*.

1942

R. H. Macy Department Store, New York, group show organized by Samuel Kootz. Rothko exhibits *Antigone* and *Oedipus*.

Wildenstein and Company, New York, *Second Annual Federation of Modern Painters and Sculptors Exhibition*. Rothko exhibits *Mother and Child*.

1943

Wildenstein and Company, New York, *Third Annual Federation of Modern Painters and Sculptors Exhibition*. Rothko exhibits *The Syrian Bull*.

Along with Adolph Gottlieb, Rothko writes a letter in response to a negative review by Edward Alden Jewell of the *New York Times*. Barnett Newman helps edit this letter.

460 Park Avenue Galleries, New York, *As We See Them*. Rothko exhibits *Leda*.

1944

Rothko and Edith Sachar divorce.

Peggy Guggenheim's gallery Art of This Century, New York, *First Exhibition in America of Twenty Paintings Never Shown in America Before*.

67 Gallery, New York, *Forty American Moderns*.

Peggy Guggenheim becomes Rothko's agent.

1945

Art of This Century, New York, *Mark Rothko Paintings*. First one-man show in a leading gallery.

David Porter Gallery, Washington, D.C., *A Painting Prophecy, 1950*. Rothko writes a personal statement for the exhibition catalogue.

67 Gallery, New York, *A Problem for Critics*. Rothko participates in a show with, notably, Jackson Pollock and Adolph Gottlieb.

Rothko marries Mell Beistle in March.

Wildenstein and Company, New York, *Fifth Annual Federation of Modern Painters and Sculptors Exhibition*. Rothko exhibits *Hierophant*.

Whitney Museum of American Art, New York. *Annual Exhibition of Contemporary American Sculpture, Watercolors and Drawings*. Rothko exhibits *Baptismal Scene*.

1946

Pennsylvania Academy of Fine Arts, Philadelphia, *The One Hundred and Forty-First Annual Exhibition*. Rothko exhibits *Landscape*.

Mòrtimer Gallery, New York, *Mark Rothko: Watercolors*. He exhibits, among other works, *Gethsemane* and *Tentacles of Memory*.

San Francisco Museum of Art, *Oils and Watercolors by Mark Rothko*. He shows, among other works, *Slow Swirl by the Edge of the Sea*.

Whitney Museum of American Art, New York, *Annual Exhibition of Contemporary American Painting*. Rothko exhibits *Room in Karnak*.

1947

Betty Parsons Gallery, New York, *Mark Rothko: Recent Paintings*.

During June and July, Rothko is guest instructor at the California School of Fine Arts in San Francisco, where he teaches ten hours a week.

Whitney Museum of American Art, New York, *Annual Exhibition of Contemporary American Painting*. Rothko shows *Archaic Fantasy*.

Rothko writes "The Ides of Art: The Attitudes of Ten Artists on Their Art and Contemporaneousness" for the journal *The Tiger's Eye* and the article "The Romantics Were Prompted" for the journal *Possibilities*.

1948

Whitney Museum of American Art, New York, *Annual Exhibition of Contemporary American Sculpture, Watercolors and Drawings*. Rothko exhibits *Fantasy*.

Betty Parsons Gallery, New York, *Mark Rothko: Recent Paintings*.

With William Baziotes, David Hare, and Robert Motherwell, Rothko founds an art school, The Subjects of the Artist, where he is one of the professors.

1949

Betty Parsons Gallery, New York, *Mark Rothko: Recent Paintings*. Rothko shows ten numbered works: *Numbers 1–10, 23*.

Whitney Museum of American Art, New York, *Annual Exhibition of Contemporary American Sculpture, Watercolors and Drawings*. Rothko exhibits *Brown and Yellow*.

In the spring, The Subjects of the Artist closes owing to financial difficulties.

Rothko is again invited to be a guest lecturer at the California School of Fine Arts.

1950

Betty Parsons Gallery, New York, *Mark Rothko*. He exhibits *Numbers 7, 10*, and *11*, among other works.

Rothko travels for the first time to Europe, accompanied by his wife. They visit France, Italy, and England.

Whitney Museum of American Art, New York, *Annual Exhibition of Contemporary American Sculpture, Watercolors and Drawings*. Rothko exhibits *Number 7A (1949)*.

Birth of Rothko's daughter, Kathy Lynn.

1951

Rothko is named assistant professor in the Department of Design at Brooklyn College, a position he holds until 1954.

Betty Parsons Gallery, New York, *Mark Rothko*. He exhibits *Numbers 1–16*.

Los Angeles County Museum, *1951 Annual Exhibition: Contemporary Painting in the United States*. Rothko exhibits *Number 11 (1951)*.

1952

Museum of Modern Art, New York, *Fifteen Americans*. Rothko exhibits with such artists as Still and Pollock.

First of Rothko's interviews with the art historian William C. Seitz.

1953

Seitz conducts two new interviews with Rothko.

1954

Sydney Janis Gallery, New York, *9 American Painters Today*.

Rothko is no longer represented by Betty Parsons; signs with Sydney Janis. He will have two one-man shows in this gallery (1955 and 1958) and take part in all of its annual exhibitions from 1954 to 1964 with the exception of 1955.

Rothko meets Katharine Kuh, art critic and curator of the Art Institute of Chicago. Exhibit there: *Recent Paintings by Mark Rothko*. Rothko and Kuh have a rich correspondence.

1955

Sydney Janis Gallery, New York, *Mark Rothko*. Still and Newman write to Janis to criticize Rothko's painting. Still denounces Rothko's "desire for bourgeois success," and Newman accuses him of being a salon painter and of subverting his work.

During the summer, Rothko is a guest lecturer at the University of Colorado in Boulder.

1957

In February and March, Rothko is the visiting artist at the Newcomb Art School at Tulane University in New Orleans.

Contemporary Arts Museum, Houston, *Mark Rothko*. He exhibits, among other works, *Number 7* and *Number 15*.

1958

Sydney Janis Gallery, New York, *Mark Rothko*.

Rothko signs an agreement to have Bernard Reis represent him during negotiations with Sydney Janis.

Venice, *XXIX Exposizione Biennale Internazionale d'Arte*. Rothko shows *Black over Reds, Deep Red and Black, Two Whites, Two Reds*, and *White and Greens in Blue and Reds*.

In July, Rothko beings work on a wall panel commissioned by the Four Seasons restaurant in the Seagram Building in New York. For the first time he composes a series, using, in addition, a horizontal format that is unfamiliar to him. Rothko will never deliver this commission. Years later, these works will go to the Tate Gallery in London.

In October, Rothko gives a conference at Pratt Institute, New York.

1959
Rothko and his family take their second European trip, visiting Italy, France, Belgium, Holland, and England.

1960
Bernard Reis becomes Rothko's financial adviser, accountant, and lawyer.

The Phillips Collection, Washington, D.C., *Paintings by Mark Rothko*.

In November, the Phillips Collection conceives and dedicates a new room to house the three Rothkos in its possession (*Green and Tangerine on Red* [1956]; *Orange and Red on Red* [1954]; *Green and Maroon* [1953]). The Phillips thus becomes the first institution to have a Rothko "room." *Ochre and Red on Red* (1954) is acquired in 1964 and added to the same room.

1961
Museum of Modern Art, New York, *Mark Rothko*. First Rothko retrospective, comprising forty-eight works, which travel to London, Amsterdam, Brussels, Basel, Rome, and Paris.

Solomon R. Guggenheim Museum, New York, *American Abstract Expressionists and Imagists*. Rothko exhibits *Reds Number 22* (1957).

Rothko begins work on the second commission that he will accept in the course of his career. Professor Wassily Leontief, chairman of the Society of Fellows of Harvard University, and John P. Coolidge, director of the Fogg Art Museum, commission this work. Rothko completes the wall panels in 1962.

1962
In the autumn Rothko, along with Gottlieb, Philip Guston, and Robert Mother-well, breaks with the Sydney Janis Gallery to protest Janis's support of New Realism and Pop Art.

1963

Solomon R. Guggenheim Museum, New York, *Five Mural Panels Executed for Harvard University by Mark Rothko.*

Rothko signs a contract with the Marlborough Fine Arts Gallery.

Christopher H. Rothko, Rothko's second child, is born at the end of the summer.

1964

First Rothko exhibition at the Marlborough New London Gallery, London, *Mark Rothko.*

In the spring Dominique and John de Menil visit Rothko in his studio and commission a series of painted panels for the Catholic chapel at the University of Saint Thomas, in Houston. Philip Johnson does the original design for the chapel but leaves the project, which is completed by Howard Barnstone and Eugene Aubry. Rothko begins work on this project in the fall.

1965

In March, Rothko receives the Brandeis University Creative Arts Awards.

1966

Another trip to Europe for Rothko and his family. They visit Portugal, Spain (Majorca), Italy, France, Holland, Belgium, and England. In London, Rothko visits the Tate Gallery, which one year earlier had expressed a wish to buy works by Rothko for a room dedicated to his painting.

1967

In April, Rothko completes the panels for the Houston chapel.

During the summer, he teaches at the University of California, Berkeley.

1968

Museum of Modern Art, New York, *Dada, Surrealism, and Their Heritage.* Rothko exhibits *Slow Swirl by the Edge of the Sea.* The exhibition travels to Chicago and Los Angeles.

In the spring, Rothko suffers an aortic aneurysm. He is hospitalized for three weeks. His doctors forbid him to paint canvases higher than forty inches. Rothko begins to work on paper and for the first time uses acrylic paint.

1969

Rothko leaves his family and moves into his studio. He nonetheless stays in touch with them.

He signs a contract with the Marlborough Gallery, thereafter his exclusive agent for the next eight years.

In June the Mark Rothko Foundation is created. Rothko receives, in addition, an honorary doctorate of fine arts from Yale University.

Rothko makes a gift of nine painted murals created for the Four Seasons restaurant to the Tate Gallery, in London. He stipulates that they must be exhibited in a specific room, without any other works.

1970

On February 25 Rothko's assistant, Oliver Steindecker, finds the lifeless body of the painter in his studio. The next day, an autopsy reveals that Rothko has died of an overdose of barbiturates after slashing his arms. The reasons that pushed Rothko to suicide remain obscure. In the last years of his life, Rothko was weakened by sickness and medications. The doctor who performed the autopsy confirmed that because of Rothko's physical condition, he would not have lived much longer. He was also under extreme pressure from his adviser and lawyer, Bernard Reis, as well as from the Marlborough Gallery.

On May 29 the Rothko room opens at the Tate Gallery.

In August, Rothko's widow, Mell, dies. Thus begins a legal battle between the heirs and children of Rothko, Kate and Christopher, and the Marlborough Gallery, a battle that the heirs would win.

Index